IMAGES
of America

THE
CROTON DAMS
AND AQUEDUCT

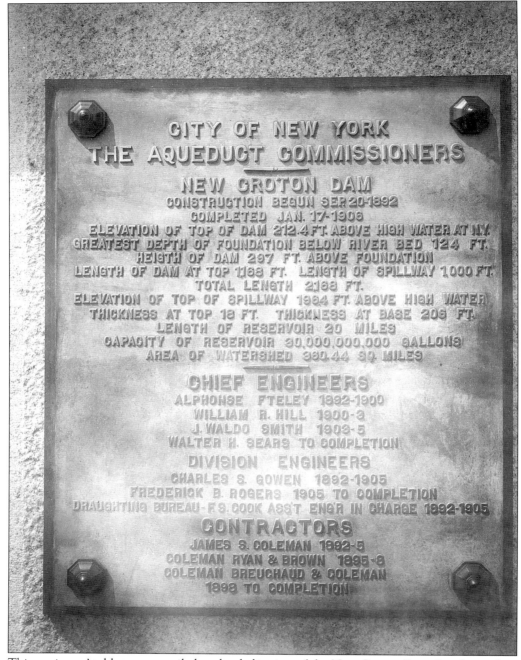

CITY OF NEW YORK
THE AQUEDUCT COMMISSIONERS

NEW CROTON DAM
CONSTRUCTION BEGUN SEP 20·1892
COMPLETED JAN. 17·1906
ELEVATION OF TOP OF DAM 212·4 FT. ABOVE HIGH WATER AT N.Y.
GREATEST DEPTH OF FOUNDATION BELOW RIVER BED 124 FT.
HEIGTH OF DAM 297 FT. ABOVE FOUNDATION
LENGTH OF DAM AT TOP 1168 FT. LENGTH OF SPILLWAY 1000 FT.
TOTAL LENGTH 2168 FT.
ELEVATION OF TOP OF SPILLWAY 1964 FT. ABOVE HIGH WATER
THICKNESS AT TOP 18 FT. THICKNESS AT BASE 206 FT.
LENGTH OF RESERVOIR 20 MILES
CAPACITY OF RESERVOIR 30,000,000,000 GALLONS
AREA OF WATERSHED 360.44 SQ. MILES

CHIEF ENGINEERS
ALPHONSE FTELEY 1892·1900
WILLIAM R. HILL 1900·3
J. WALDO SMITH 1903·5
WALTER H. SEARS TO COMPLETION

DIVISION ENGINEERS
CHARLES S. GOWEN 1892·1905
FREDERICK B. ROGERS 1905 TO COMPLETION
DRAUGHTING BUREAU· F S. COOK ASS'T ENGR IN CHARGE 1892·1905

CONTRACTORS
JAMES S. COLEMAN 1892·5
COLEMAN RYAN & BROWN 1895·8
COLEMAN BREUCHAUD & COLEMAN
1898 TO COMPLETION

This engineers' tablet was unveiled at the dedication of the New Croton Dam. It is located on the head house nearest to the spillway on the top of the dam.

IMAGES
of America

THE
CROTON DAMS
AND AQUEDUCT

Christopher R. Tompkins

ARCADIA

First printed in 2000.
Reprinted in 2002, 2003.

Published by Arcadia Publishing,
an imprint of Tempus Publishing, Inc.
2A Cumberland Street
Charleston, SC 29401

Printed in Great Britain.

Library of Congress Catalog Card Number: 00-104058

For all general information contact Arcadia Publishing at:
Telephone 843-853-2070
Fax 843-853-0044
E-Mail sales@arcadiapublishing.com

For customer service and orders:
Toll-Free 1-888-313-2665

Visit us on the internet at http://www.arcadiapublishing.com

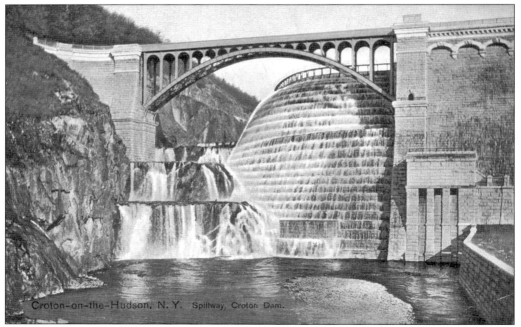

The New Croton Dam, an architectural marvel, is worthy of a postcard. (Courtesy Chester and Elizabeth Tompkins.)

CONTENTS

Acknowledgments 6

Introduction 7

1. The "First Family" 9

2. The Old Croton Dam 17

3. Excavating the New Croton Dam 29

4. Building the New Croton Dam 49

5. A Changing Landscape 81

6. New and Old Faces 97

7. The Test of Time 115

ACKNOWLEDGMENTS

I wish to dedicate this volume to my parents, John R. Tompkins and Marie H. Tompkins, who taught me the value of honesty and integrity and gave me a love of the outdoors, and to my grandfather, the late John M. Tompkins, who introduced me to the wonders of the Croton Watershed and gave me most of these historic photographs.

Special recognition is extended to Katherine and Hannah Tompkins for all the hours they endured with me in front of the computer; to Amy Bell Sessler for her expertise in photography and encouragement; to Chester and Elizabeth Tompkins for helpful letters and interesting Croton trivia; and to Historic Hudson Valley Inc. for providing photographs and years of pleasure at their historic sites.

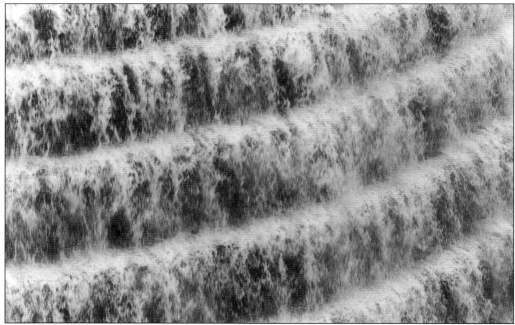

With its tiers, or steps, the spillway is famous for its noise and beauty. (Courtesy Amy Bell Sessler.)

INTRODUCTION

To the countless children who have persuaded their parents to take them sledding at the dam, the only thing that seems important is how much snow is on the ground and whether a friend will come along. Few people give a second look at the plaques found on the masonry dam, yet they tell an important story: that this New Croton Dam is not the first. In fact, the New Croton Dam is the second dam to hold the waters of the Croton River in check for use nearly 40 miles away in New York City.

As far back as the 18th century, New York City was seeking a source of water, both clean and constant. By the time of the American Revolution, Manhattan Island was suffering from a lack of potable water. Wells that had been sunk on the public streets provided some relief, and the Collect, a pond of some 48 acres, offered further access to water. With the onset of the Revolution, the water question had to wait.

North of the city, in what was then the neutral ground of northern Westchester County, the Croton River offered a natural divide between the British, who held New York, and the American troops to the north. Flowing out of White Pond near the Connecticut border, the Croton River meandered through today's North Salem, Bedford, Somers, Yorktown, Cortlandt, and New Castle. It flowed into the Hudson River at Teller's Point, today simply known as Croton Point in the Village of Croton-on-Hudson.

The Croton River was more than a dividing line in a war. It was an active route of commerce, serving mills and farms well inland from the Hudson. The waters were filled with native species of fish and could be counted on to run year-round. The Croton River, however, had a history of rapidly changing from a bucolic trade route into a raging tempest. Whether from heavy rain or rapid snowmelt, the river periodically destroyed everything in its path.

As New York City grew in the post-Revolutionary era and the existing sources of water became obsolete, various commissions and politicians debated the costly options for clean water. Several ideas were put forward, including damming the Hudson River, but all were deemed to be ridiculous or inadequate. The early 19th century was, however, a time of great technological advancement in the United States. New York had already seized control of eastern shipping by punching the Erie Canal through western New York. Such an engineering feat secured New York's place as the primary East Coast port and guaranteed considerable growth as a result. Fortunately for New York, the same sense of manifest destiny that was sending the population west and the grain east through the Erie Canal brought together engineering minds to cure the city's insatiable need for water.

As fires and epidemics ravaged the city of New York in the early 19th century, a farm boy

turned engineer was cutting "Clinton's Ditch," the Erie Canal, across upstate New York. John B. Jervis learned his trade in the field as an axman, then a surveyor, and finally a civil engineer. It was Jervis who became the chief engineer for the old Croton Dam and Aqueduct, which were begun after a report on water quality that established raw sewage and seepage from stables and graveyards was contaminating Manhattan's water.

Between 1837 and 1842, the old Croton Dam and Aqueduct were constructed with the help of Irish immigrants and contractors with names as old as New York. During the construction of the dam, in January 1841, a massive storm dumped 18 inches of snow followed by three days' worth of rain. In one of the Croton River's many tempestuous episodes, it rose 15 feet above the spillway and washed most of the dam away. The flood took both lives and livelihoods when the sediments that were deposited at Teller's Point closed the river to commercial traffic for good.

Following the flood, the old dam was rebuilt with modifications to the structure to protect it from future storms. The valley returned to its traditional peaceful state, as New York City basked in the triumph of bringing water nearly 40 miles to Manhattan. Access to a supply of water "in perpetuity" (or so they thought) supported a burgeoning population. Following the Civil War, New York's population swelled to well over 1 million, with water consumption nearly doubling from prewar records. Water meters were installed and accusations of corruption in the water department became a part of the tabloids. New York was heading toward another water crisis and turned again to the Croton Watershed.

By 1875, surveys for a new and larger aqueduct and dam were started. Research was completed on masonry dams in Europe and in the United States. What was planned rivaled all previous masonry structures: a dam rising 214 feet above the valley floor—some 136 feet higher than anything else in the United States and 50 feet higher than the largest in France. The new dam was to become another engineering first in the United States and was to bring more change to New York and Westchester County.

The New Croton Dam was started in 1892 and completed in 1906. The dam forced the removal of farming families along the Croton. Hundreds of Italian and Irish immigrants moved their entire families to Croton and Ossining, where they settled and remain part of the local community today. Many other nationalities as well as African Americans made their way to the project for work. The dam created new wealth for some and forced others to find new livelihoods, often working for the water department.

Today, the dam remains a symbol of 19th-century optimism and excitement. It has withstood the various tests of time—an expanding population of New York, the newer Catskill Aqueduct, periodic floods, and even the encroachment of population within the watershed. The dam remains a destination for families and tourists alike. It offers a glimpse of the past and a glorious place for children growing up in the area to scream as their sleds move down embankments that once carried railcars with cyclopean stones to the face of this magnificent structure.

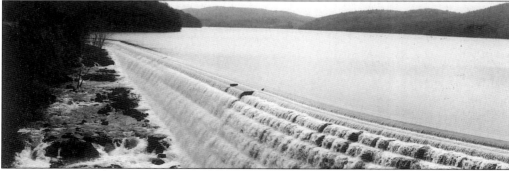

The full length of the spillway is 1,000 feet, its graceful curves broken by the jagged rocks below. (Courtesy Amy Bell Sessler.)

One
THE "FIRST FAMILY"

Having owned more than 80,000 acres in northern Westchester County, the Van Cortlandt family deserves the title bestowed on them in this chapter. Their Royal Manor, granted under King William III of England, extended nearly the length of the Croton River and used much of the lower Croton River as a boundary line. The family controlled the river crossings and access to land. Many of the families mentioned in this book purchased their land from the Van Cortlandts in the 18th and 19th centuries. Like their tenants, the Van Cortlandts were a presence, no longer an influence, on the river into the 20th century. Their Manor House, now a historic site, remains a sentinel at the mouth of the river to this day.

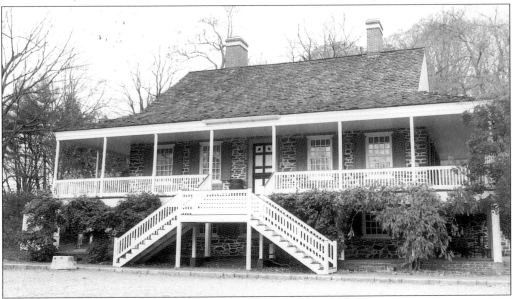

Van Cortlandt Manor stands frozen in time before the construction of the old Croton Dam. Legend holds that floodwaters from the 1841 dam break rose to the front steps. (Courtesy Amy Bell Sessler.)

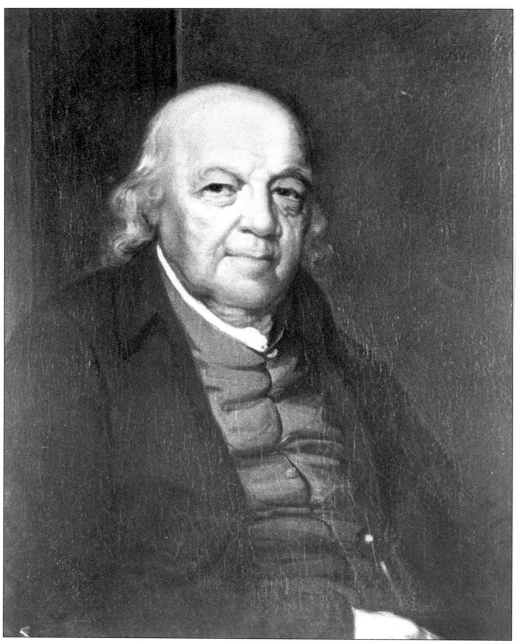

Pierre Van Cortlandt lived from 1721 to 1814 and witnessed the many changes in New York and the Croton Valley. His home stood on the edge of no-man's-land during the American Revolution and was abandoned by the family, who sided with the patriots and moved north behind the American lines. He was the first lieutenant governor of the state of New York and had frequent house guests at the Croton Manor, including notables such as Benjamin Franklin, who arrived by boat at the family's private dock on the Croton River. The family held title to many tenant farmers' plots but slowly sold off land to freeholders before and after the war. (Courtesy Historic Hudson Valley, Tarrytown, NY.)

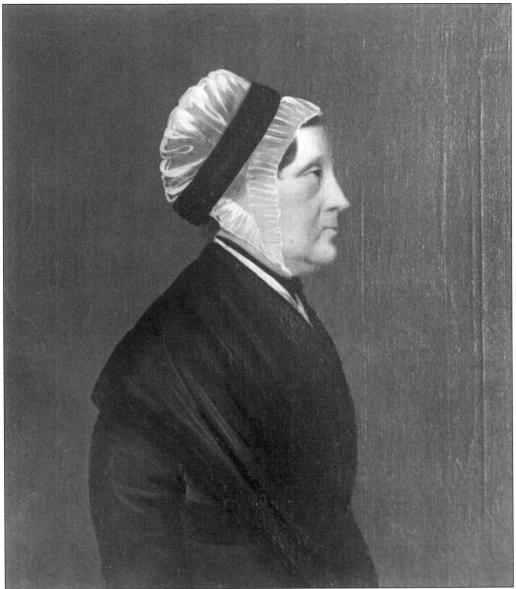

Joanna Livingston Van Cortlandt lived from 1722 to 1808, nearly as long as her husband, and was the lady of the manor while he was away for political reasons. She was a daughter of the Hudson Valley's most prominent family, the Livingstons of Livingston Manor, and spent a great deal of time during the Revolution at her relatives, the Beekmans. The Van Cortlandts were one of the only families in the Croton Valley to own slaves, who primarily worked around the manor house. Following the Revolution, Pierre and Joanna Van Cortlandt built a new home in Peekskill and handed the Croton Manor to their son. (Courtesy Historic Hudson Valley, Tarrytown, NY.)

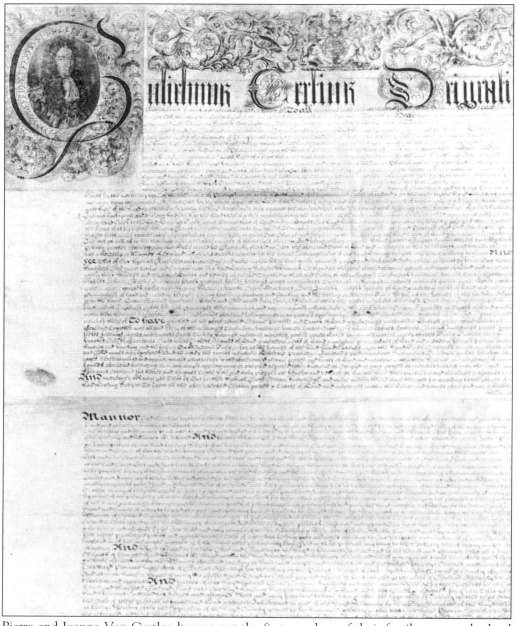

Pierre and Joanna Van Cortlandt were not the first members of their family to own the land along the Croton River. Earlier Van Cortlandts arrived in the New Amsterdam Colony in 1638. By 1697, the family had acquired enough status under Dutch rule (and after 1664 under English rule) to receive a Royal Charter establishing the Manor of Cortlandt. As a Royal Charter issued by King William III, English rules of primogeniture were set out but were not followed by the Dutch Van Cortlandts. Once the family broke up the estate between male heirs, the status of Royal Manor ended. By the time Pierre Van Cortlandt became lord of the manor, he was more of a senior partner managing his and his brother's landholdings along the Croton River. (Courtesy Historic Hudson Valley, Tarrytown, NY.)

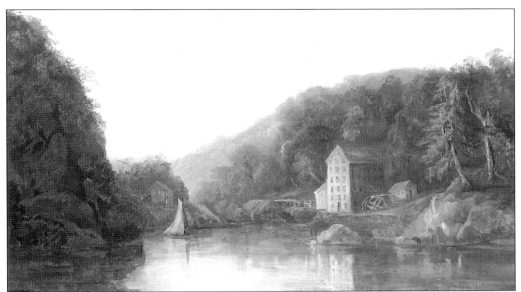

The Royal Charter issued in 1697 gave the Van Cortlandts all the privileges of establishing and controlling ferries and bridges on the Croton River. The family was granted rights in English tradition to wild game, fowl, and fish, as well as to establish mills on the river. This painting of a mill on the Croton River was probably painted while the old Croton Dam was under construction and just before the 1841 flood that likely destroyed most of the building. (Courtesy Historic Hudson Valley, Tarrytown, NY.)

As roadways were constructed and river crossings became necessary, a ferry was put into service near the Van Cortlandt Manor House. It conveyed travelers and stagecoaches on the Albany Post Road across the Croton River near its mouth. Travelers were offered lodging and meals at the Ferry House on the north shore. The bell in the foreground was likely on the south shore of the Croton River and was used to summon the ferry master. (Courtesy Amy Bell Sessler.)

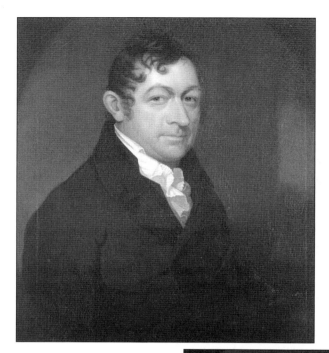

Pierre Van Cortlandt Jr. followed his father into politics and the eventual management of the remaining estates in the Croton Valley. A member of the New York Assembly, he was the patriarch of the family when the old Croton Dam was constructed. His first wife was the daughter of Thomas Jefferson's vice president, George Clinton. (Courtesy Historic Hudson Valley, Tarrytown, NY.)

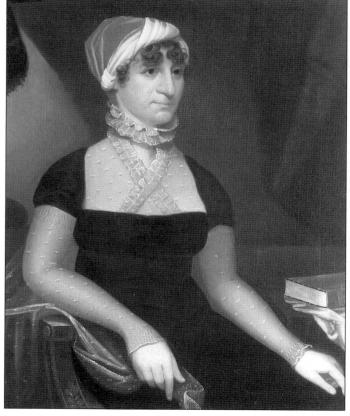

Ann Stevenson Van Cortlandt was Pierre Van Cortlandt's second wife and the mother of Pierre Van Cortlandt III. She came from another New York political family. During the time of her marriage, the mills and agriculture along the northern sections of the Croton River flourished. (Courtesy Historic Hudson Valley, Tarrytown, NY.)

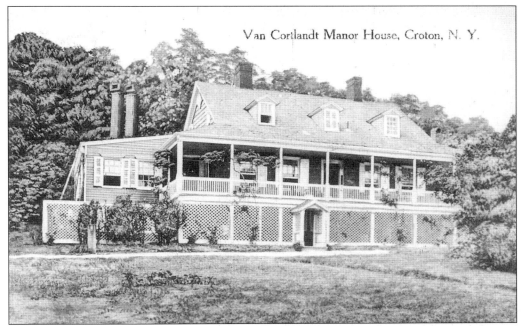

This *c.* 1920 postcard commemorates the Van Cortlandt family's instrumental role in the development of northern Westchester County and the importance of the Croton Valley in that growth.

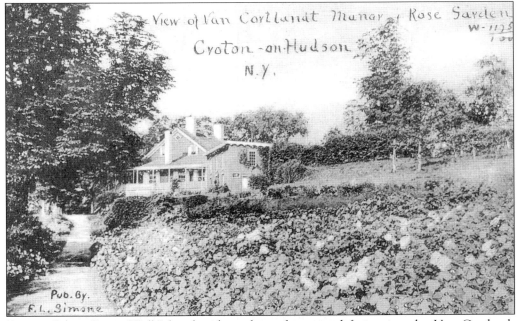

Famous for its "Long Walk" lined with gardens of roses and fruit trees, the Van Cortlandt Manor House, *c.* 1920, became a favorite destination along the Croton River as tourism replaced agricultural pursuits in the 20th century.

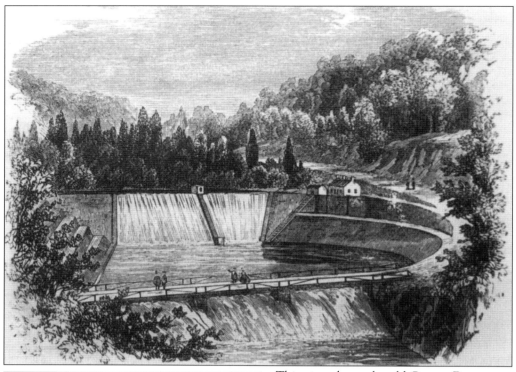

This view shows the old Croton Dam much as it would have looked during Pierre Van Cortlandt Jr.'s final years on the manor. As a major engineering achievement, the dam was captured in various prints and tabloids for the urban public to see. Early prints sought to soften the environment, but reality was a more rugged landscape, as seen below.

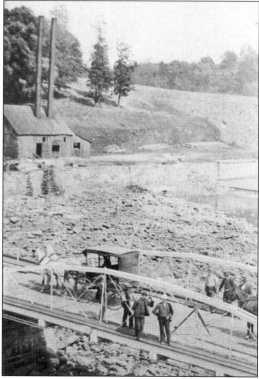

This rare *c.* 1870 image shows a mill below the dam that was removed before the beginning of construction of the New Croton Dam. Note the surveyors on the bridge, beginning the research for the new dam.

Two
THE OLD CROTON DAM

There is little in the photographic records to fully detail the construction of the old Croton Dam. Irish immigrants came to the Croton Valley to construct the dam and to complete the true engineering feat—the aqueduct. When tragedy struck and the dam broke, the valley was devastated, but New York was forced to pay restitution to many families. The dam heralded a new era for New York City, with clean and constant water available through the amazing Croton Aqueduct. For the people of the Croton Valley, it meant lower water levels in the river and a vastly changed landscape.

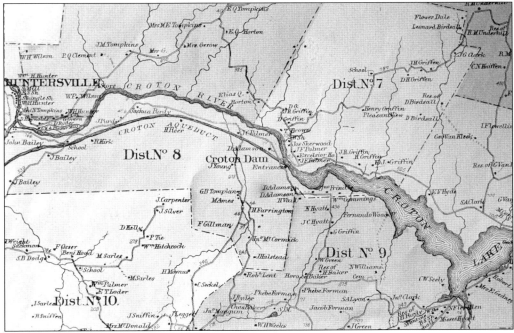

This 1867 map of Yorktown shows the Croton Reservoir, River, Dam, and Aqueduct and the local families whose lives centered on the river.

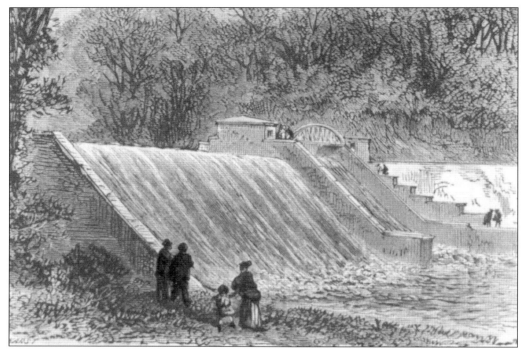

Early prints of the Croton Dam sought to create a bucolic setting. The forest surrounding the dam was, at the time, mostly fictional because much of the landscape had been cut for pasture. Today, however, the watershed offers lush foliage for visitors to the area.

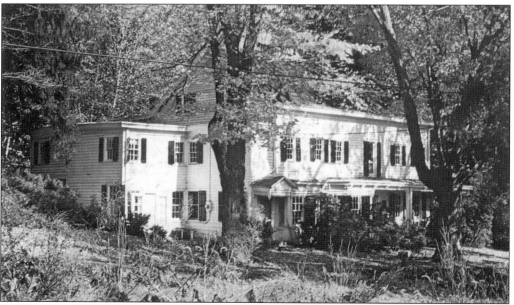

At the time of the Revolution, the Davenport House had an unobstructed view of the Croton River several miles away. The house was held by African American troops who were massacred by English regulars. A belated monument was erected at another colonial locale, the Presbyterian church at Crompond Corners, the old center of Yorktown.

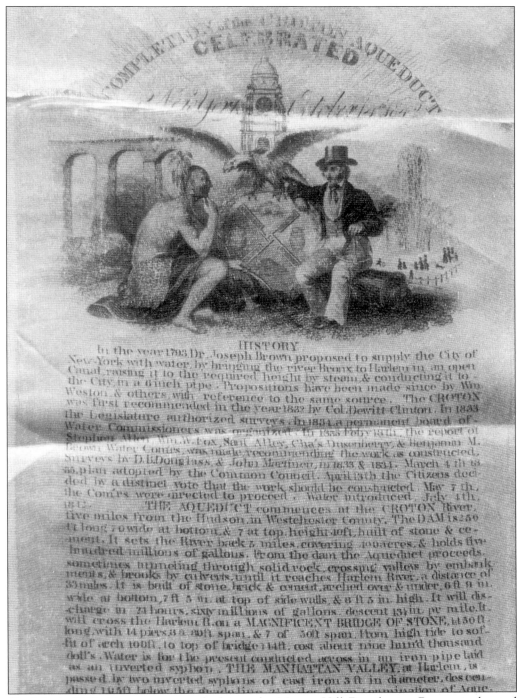

On July 4, 1842, Croton water gushed into the Murray Hill Distributing Reservoir, located where the New York Public Library sits today. The silk ribbon shown here signified the public celebration in October 1842. The event was one of the largest public demonstrations in early New York, with parades, speeches, and general celebration.

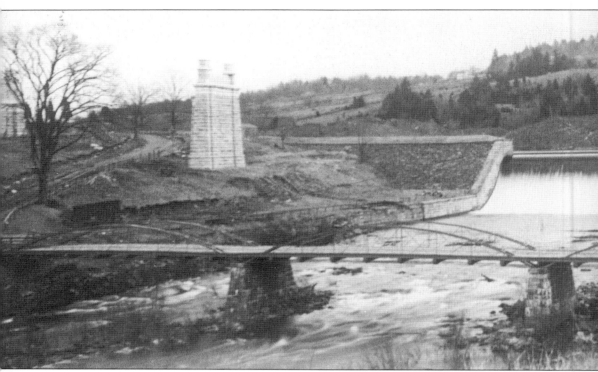

While this photograph clearly dates to *c.* 1900, the old Croton Dam, gatehouse, bridge, and surrounding farmland are clearly visible as they would have been at the completion of the old dam. Note that the mill is long gone, as the shifting needs of New York City and a changing economy affected the traditional lifestyles of Westchester County's older inhabitants. This

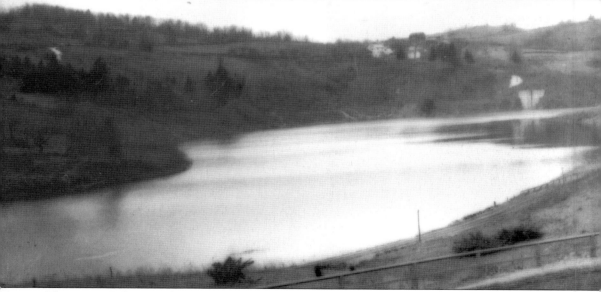

This *c.* 1895 photograph offers a sense of the size of the old Croton Reservoir compared to the new lake, which later rose to the top of the stone berm seen at the right. The old reservoir

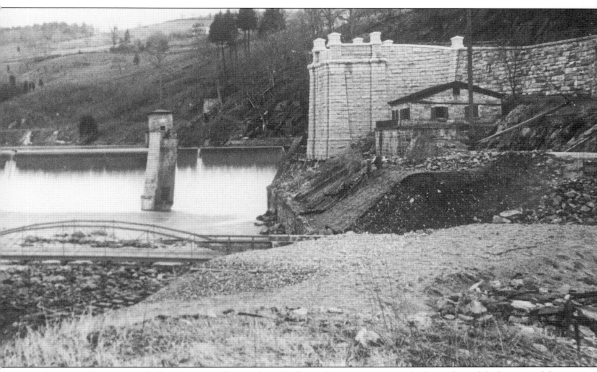

Croton Dam raised the Croton River by 40 feet. It was estimated that the old dam could provide water sufficient for upward of 1.75 million people. Even during record dry spells, the capacity of the Croton Reservoir was thought to provide 62.5 days of water for New York City.

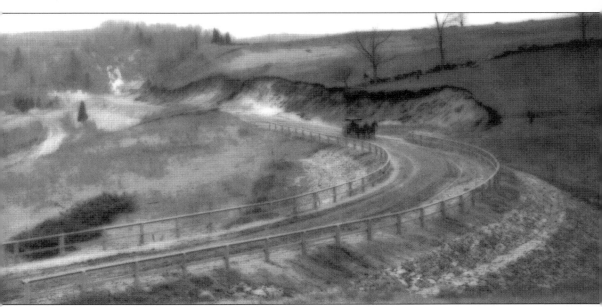

stretched for 5 miles behind the dam; the new reservoir was to be more than 20 miles long.

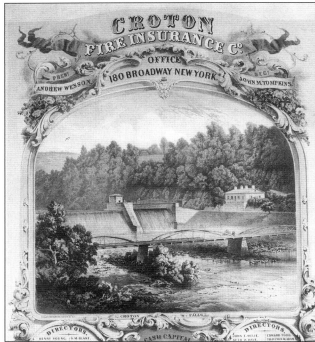

With some irony, the erroneously labeled "Croton Falls" were used to advertise the Croton Fire Insurance Company. After the Great Fire of 1835, it was no wonder that the image of the dam that reduced the ravages of disease and fire would have been used to sell insurance. For the record, Croton Falls is a stop on the Harlem Line of the Metro-North Railroad and is located in northeast Westchester County.

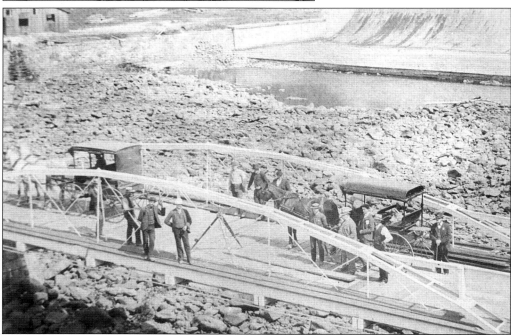

Looking carefully at the dam behind these gentlemen, one can see that either the weather is extremely dry or that New York City was consuming far too much water. The spillway is dry and the riverbed below the bridge is empty of water. Early dams did not seek to keep river water levels at any particular level. The Croton River would periodically go without or with very little water until it met the Hunter's Brook several miles downstream.

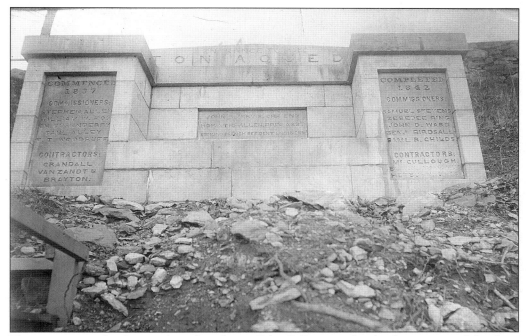

The entrance to the Croton Aqueduct, listing John B. Jervis as the chief engineer and the dates 1837–1842, is located high above the original intake tunnel of the old Croton Dam. These tablets sit high above the waters of the lake on a steep embankment but are still visible from the gatehouse bridge in Yorktown.

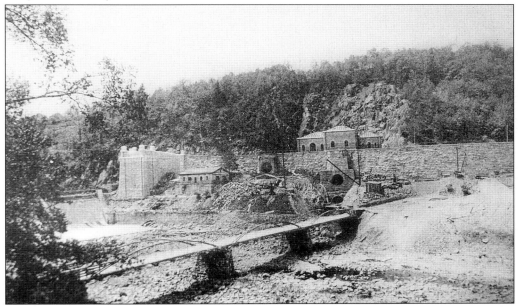

With work on the new aqueduct surrounding the old Croton Dam, it is clear to see the scope of the new project compared to that of the old one. The gatehouse, the bridge, and the intakes alone mute the grand success of the previous dam, completed fewer than 50 years before this *c.* 1895 photograph.

This view was taken from the Croton Aqueduct, looking across to the confluence of the Hunter's Brook and the Croton River. While difficult to discern, the lush valley is primarily farmland, with pastures and orchards visible in the upper right. At the lower left is the wire mill and wire mill bridge, built in the early part of the 19th century. Only a few years later, the scene was completely different, as surveyors, axmen, bricklayers, and water cut a path through the valley to build a new dam and reservoir.

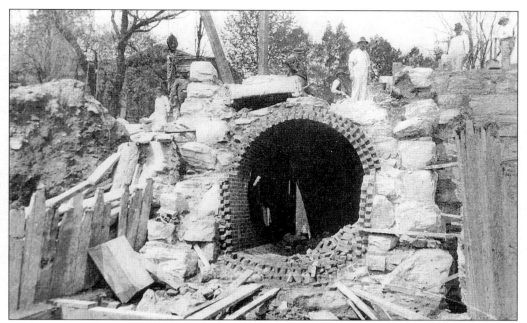

While likely a photograph of the new aqueduct, this scene depicts similar conditions to those in 1840 when Irish laborers worked to bring water to New York. The brick-lined tunnels carried water over 30 miles and showed signs of disrepair, as New York demanded maximum output from the reservoir. Eventually, water was turned off for days at a time to complete repairs.

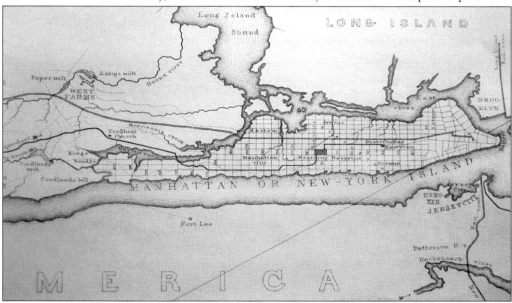

This Hydrographic map *c.* 1895 from Description of the New-York Croton Aqueduct by T. Schramke shows the route of the aqueduct. Manhattan received its water through tunnels by way of an inverted siphon and gravity flow all the way from Yorktown. At a time when there were few roads through northern Westchester County, the engineering involved in the construction was ingenious.

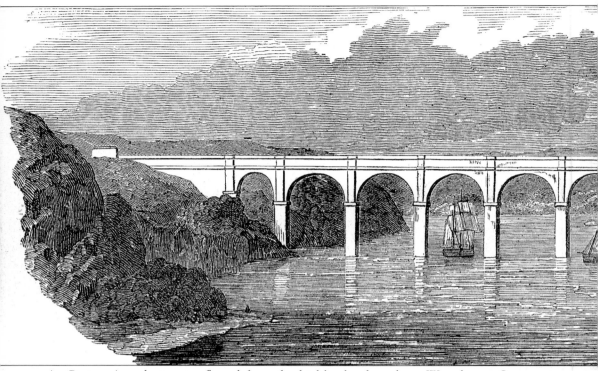

As Croton Aqueduct water flowed from the highlands of northern Westchester County, it encountered several rivers and small valleys. These geographical nuisances were overcome by the engineering of John B. Jervis with aqueduct bridges, much like those seen in the Roman world. The High Bridge over the Harlem River is the most famous of these structures and

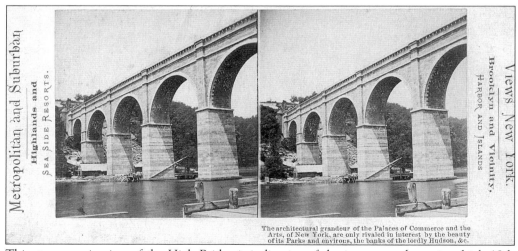

The architectural grandeur of the Palaces of Commerce and the Arts, of New York, are only rivaled in interest by the beauty of its Parks and environs, the banks of the lordly Hudson, &c.

This stereoscopic view of the High Bridge is indicative of the interest and awe in which 19th century New Yorkers and visitors alike held the Croton System. The series of stereoscopic images also includes statues of Revolutionary War heroes, natural wonders such as the Caterskill Falls, and the York Hill Reservoir in Central Park, now the Great Lawn. Obviously, though, someone forgot to tell this photographer that he was not on the banks of the "lordly Hudson."

26

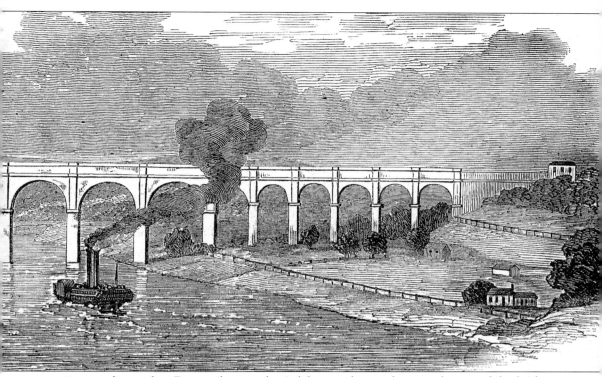

remains standing today. During the aqueduct's lifetime, the conduits on the top of the bridge were expanded to allow more water to flow into New York. Eventually the railroads, an interstate highway, the neighborhoods around Yankee Stadium, and those across the river in Harlem encroached on this once rural setting. (Courtesy the *Illustrated London News.*)

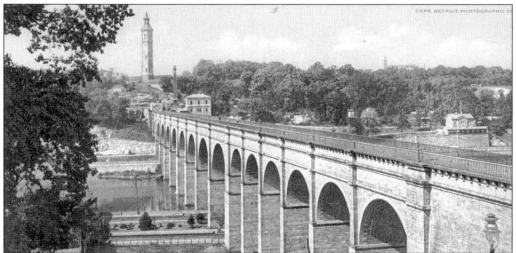

By the end of the 19th century, the High Bridge had become a social gathering point, with families walking its length on Sunday afternoons. Surrounding the bridge, the growth of New York is evident, including railroad tracks on the water's edge. The large structure on the opposite bank is a ventilation tower for the aqueduct. The High Bridge, along with the old Croton Dam, were placed on the National Register of Historic Places in 1973.

As of 1849, pursuant to an act of the legislature, New Yorkers had to pay "water rent" on an annual basis. This receipt is from the first years of the system and charged John Brown $29 for the period from May 22, 1850 to May 1, 1851, for water used at One Bridge Street. The reverse of his receipt offers a glimpse at the level of seriousness the water commissioners viewed the use of the water and the massive investment made in building the dam and aqueduct. The rules state that a tenant could not share water nor alter any conduits or pipes to supply water to others. Tenants had to maintain their own plumbing, and water could only be used to wash the streets before 8:00 a.m. and after 7:00 p.m.. Furthermore, injury to a fire hydrant was an offense with a $20 fine, plus the cost of repair. There were no rights listed for the tenant, and water could be turned off at the discretion of the board. Some recipients of Croton water wondered about the minnows that periodically appeared in people's tap water.

Three
EXCAVATING THE NEW CROTON DAM

While the true engineering feat of the old Croton Dam and Aqueduct was the aqueduct, the opposite was true with the New Croton Dam. This time, the dam was the true monument. With a spillway 1,000 feet in length and well over 200 feet in height, this new dam was designed to retain upward of 30 billion gallons of water at an elevation (depth) of 200 feet at the dam. Often forgotten or misunderstood is the depth to which the engineers had to excavate to prepare the gorge for the visible dam: 124 feet below the bed of the river.

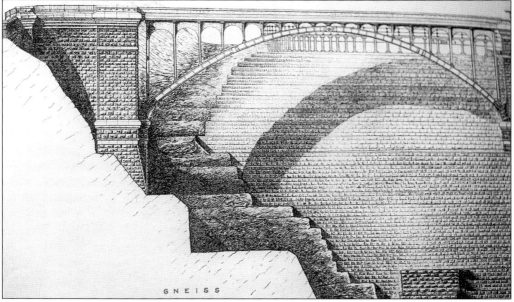

GNEISS

Even the plans for the grand spillway and 200-foot arch bridge depict a monument in the making.

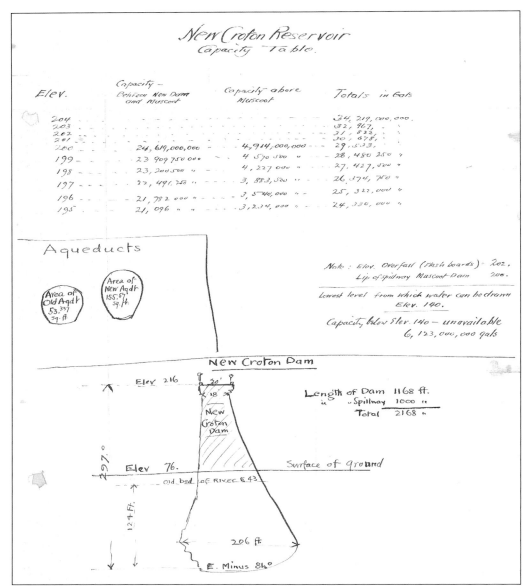

Assistant engineer John W. McKay wrote extensive notes in 1890 regarding the aqueduct and dam. He examined the tides along the Harlem River in New York City and conducted extensive equations on tunnel size and the flow of the aqueduct at certain locales. These handwritten notes offer an overview of the new dam and some comparison between old and new aqueducts. Note the area of old aqueduct tunnel at just over 53 square feet versus the area of the new aqueduct tunnel at just over 155 square feet.

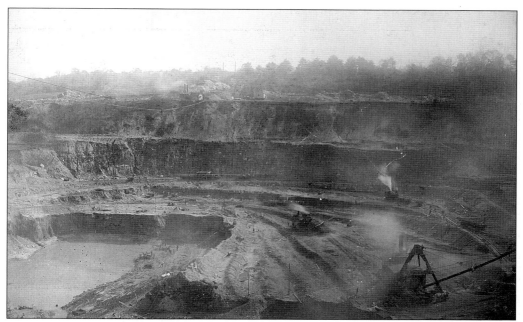

Excavation for the New Croton Dam was well under way in October 1895. Enormous steam shovels peeled away the earth of the steep valley walls of what once was the Cornell Farm. Some people even refer to the dam as the Cornell Dam, but this is a misnomer. The pit needed to be dug well over 100 feet below the existing bed of the Croton River, thus causing water seepage from a high water table. Erosion was a constant concern as well. At the bottom of the photograph, note the retaining wall that used to hold back the Croton River.

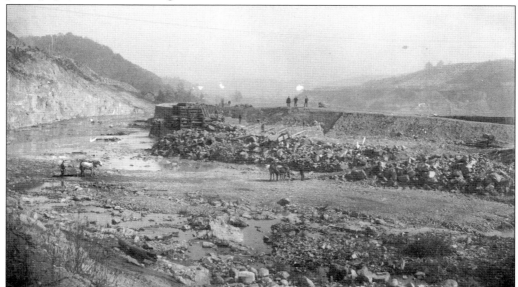

While the excavations were taking place below the level of the riverbed, the Croton River continued to flow. The retaining wall and berms used to control the flow of water in the Croton River were not always sufficient. At times, the river would fill the entire channel and spill over into the excavation. This photograph dates from *c.* 1895

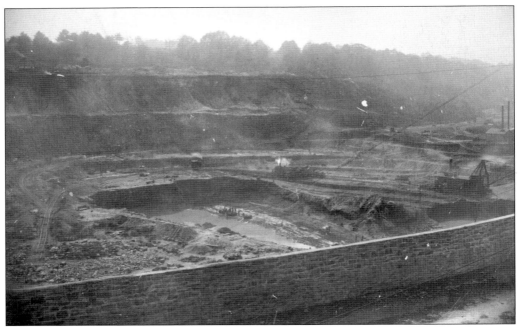

Existing technology in 1895 included a mix of steam power, horsepower, and human power. Steam powered both the large shovels that excavated the soil and stone as well as the trains that were used to haul away the fill.

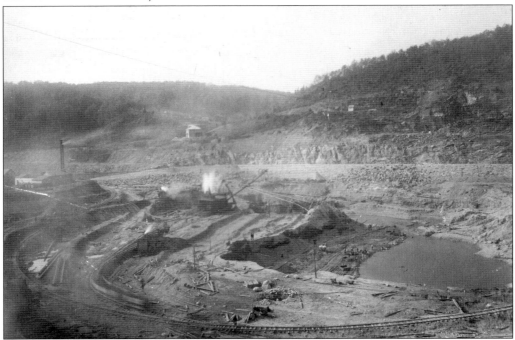

Deep in the big hole, a pair of horses drag a cart of mud after it has been filled by hand labor. This photograph offers a near perfect view of the site where the dam was built ten years later, in 1905.

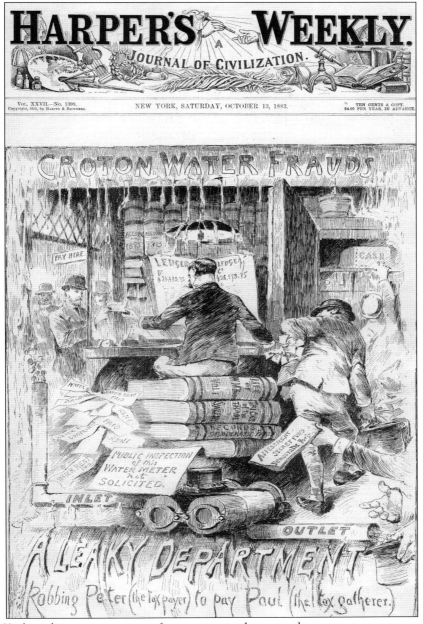

In New York tradition, accusations of corruption in the water department were rampant in the early 1880s. With the old aqueduct under strain as a result of post-Civil War growth and aging aqueduct tunnels needing repair, questions were raised about where the "water rent" was going. Tammany Hall was a backroom player in the process to build the dams and aqueducts; thus the Democratic party was the focus of some accusations of a secret slush fund. Still other voices simply argued that the funds went directly into the pockets of the employees of the water department. With improvements in city government and with the water supply in the early 20th century, accusations eased off and were directed toward other departments and new issues. (Courtesy *Harper's Weekly*, 1883.)

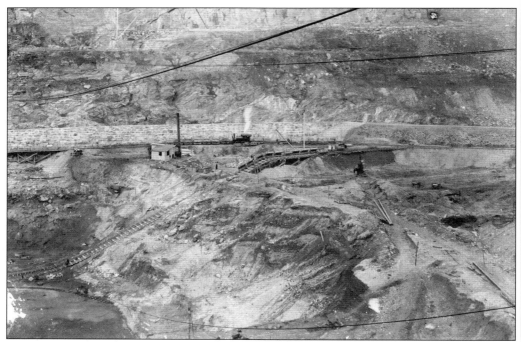

Work to excavate to the rock bottom continued at a fevered pitch in the winter of 1896. Note the lack of snow on the hillsides. Perhaps the traditional January thaw gave workers a brief respite from the traditionally cold and blustery weather in the area.

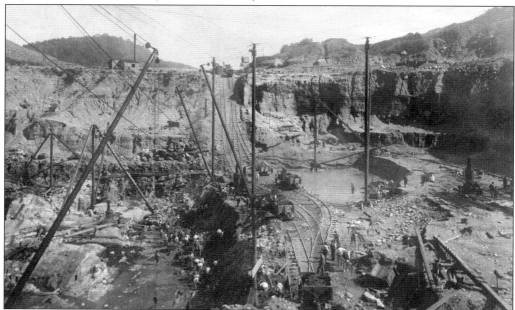

Looking deep into the pit, one can almost hear the sounds of men grunting under the strain of lifting shovelfuls of dirt into railcars lowered into the work area by cables. The grade was far too steep for engines to descend into the pit. The tall poles with cables are derricks and pulleys used to hoist and move equipment and stone.

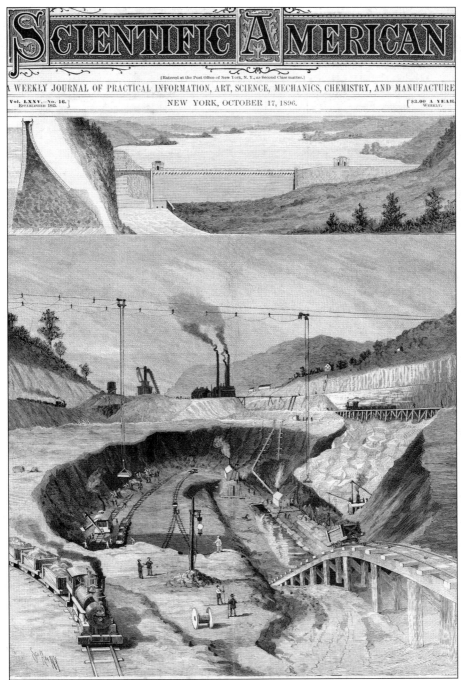

SCIENTIFIC AMERICAN

[Entered at the Post Office of New York, N. Y., as Second Class matter.]

A WEEKLY JOURNAL OF PRACTICAL INFORMATION, ART, SCIENCE, MECHANICS, CHEMISTRY, AND MANUFACTURE

Vol. LXXV.—No. 16.
ESTABLISHED 1845.

NEW YORK, OCTOBER 17, 1896.

[$3.00 A YEAR.
WEEKLY.

During the course of the project, *Scientific American* dedicated several cover pages to the construction of the New Croton Dam. This cover is especially noteworthy for its accuracy in depicting the excavation and for the comparison-planning image at the top. See the original photograph on the previous page for comparison. Note the overhead pulleys and carts, as well as the railcar moving up from the pit via cable. (Courtesy *Scientific American*, 1896.)

35

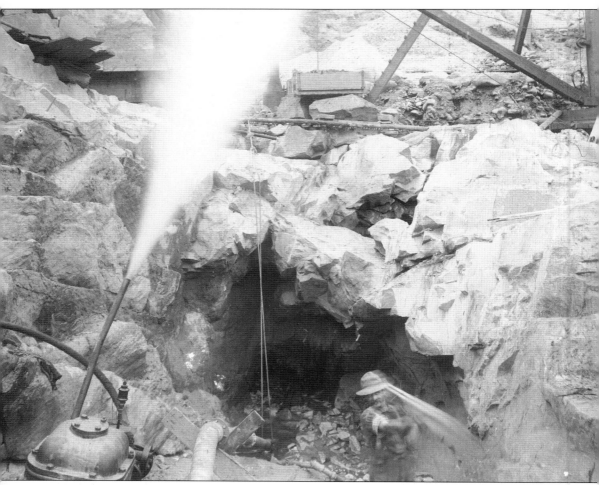

Steam power was busy running sump pumps to drain the water from the hole below. Such noise and conditions were no issue for the laborer seen swinging his pick without eye or ear protection.

Few photographs of the quarry are available today. This view offers a rare glimpse of the conditions found several miles away in the town of Cortlandt, where stones were cut and finished, mostly by Italian immigrant labor. Safety standards and the health of quarrymen were rarely of the utmost importance. Oral history tells of a cable snapping, allowing one of the enormous stones to fall and crush a worker. The workday proceeded, however, and only after the final whistle did a funeral wagon pick up the crushed remains. Stones were numbered for specific use in the construction of the dam and loaded onto railcars, using the derricks and pulleys. Once stones reached the dam, they were fitted into place using their numbers. Below, the first stones laid were more than 100 feet below the riverbed.

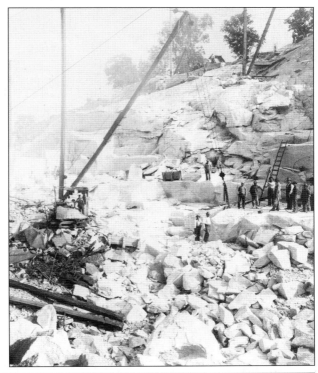

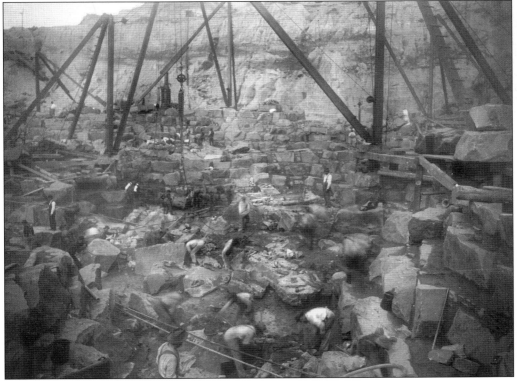

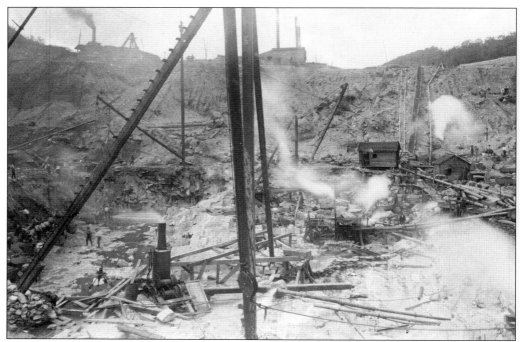

It is clear from these photographs that OSHA standards have improved safety at industrial and construction sites dramatically since the beginning of the 20th century. Below, note the handmade ladders and scaffolding that cling to the stone face below the construction office. The excavation of the dam was nearing completion by 1897, but the threats of water and erosion were still present, as seen in both photographs.

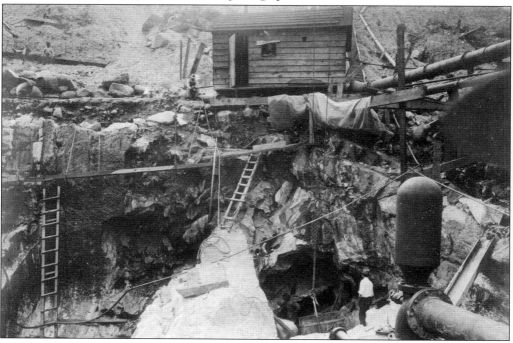

More than one child worked on the construction of the dam. This boy teeters on the edge of a derrick a good 30 feet above the top of a water-filled pit, c. 1896.

By late 1896, erosion had taken its toll on the steep face of the excavation for the dam. Below, steam shovels and men raced against the weather with the help of massive steam boilers used to generate sump and pulley power in the pit. Boys such as the one above made their way through this maze of equipment, wires, and stone to make money for their families.

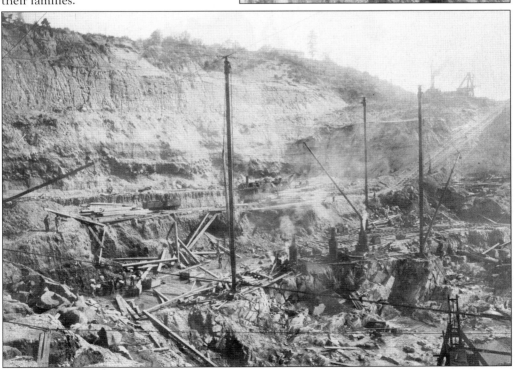

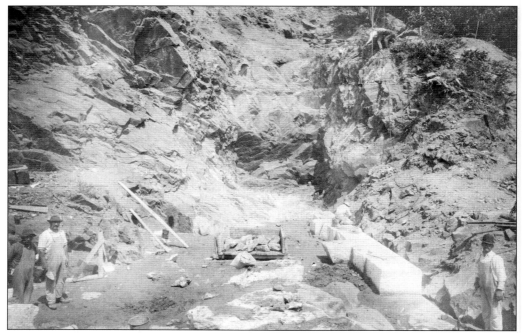

The first finished stones were placed on the solid rock bottom of the excavation of the spillway in 1897. Many of these workers, along with contractors, mayors, and commissioners, did not remain on the project to its completion. Note the large wooden mallet at the lower left, which was used to tamp the stones into place, and the men perched precariously on the rock face above the foundation stones.

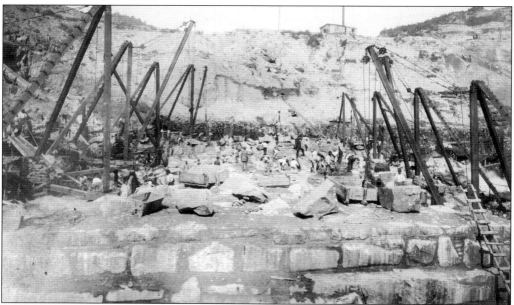

As excavation turned to laying stone, the ongoing process of filling the 126-foot hole in the ground began. Workers focus on the core of the base of the massive project with cyclopean stones hauled from the quarry.

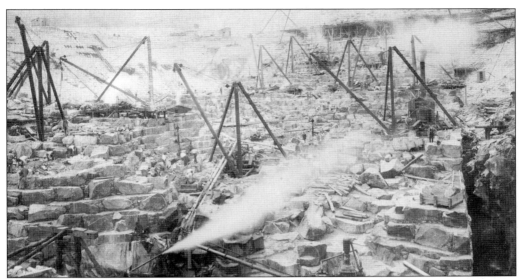

May 26, 1897, marked the one-year anniversary of the start of heavy construction. Despite the use of fairly basic technology, the project was well under way and the deep pit was rapidly filling with the stone masonry foundation of the dam.

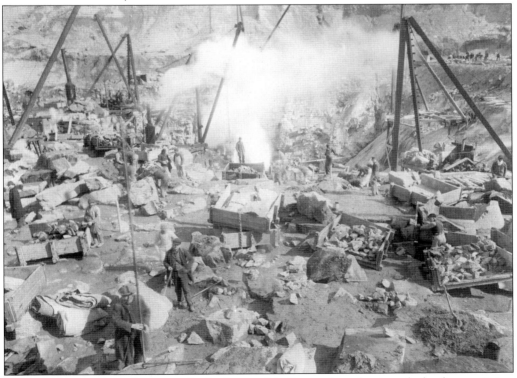

The steam rising from the pit in the background indicates that, despite a lack of snow, it is a frigid February day in 1897. While overcoats seem to have been the rule, many of the men in the picture have nothing on their hands. To the left, a stoneworker smokes a pipe to keep warm, and in the center against the steam a man in a top hat makes the rounds.

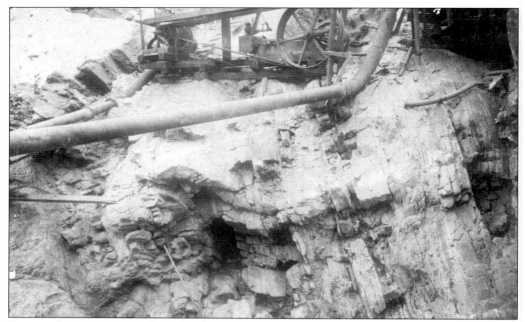

Even as the masonry rose from the floor of the excavation, sump pumps were almost always in action to keep up with seepage and collecting rainwater.

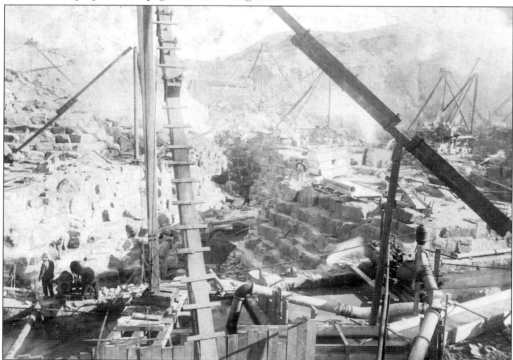

Technology changed and improved during the construction of the dam. In this 1897 photograph, an old sump pump to the right is being augmented and replaced by a newer, smaller pump to the left.

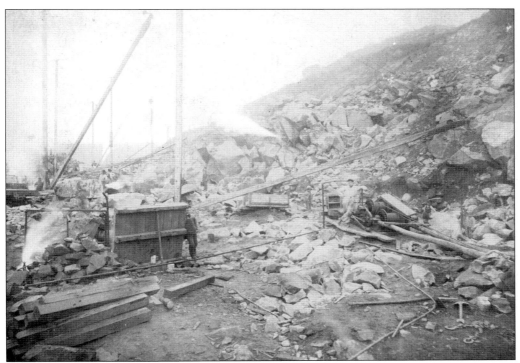

A project of this magnitude brought with it significant dangers. While there is no written record to support the age-old story of people being left to die in cement, there were very real hazards that at the very least injured people. These two photographs show seemingly nonchalant workers posing amidst a massive rock slide in the quarry in November 1897.

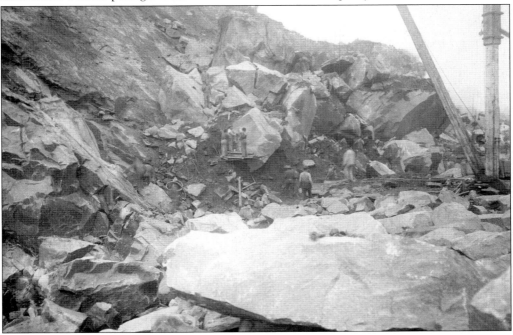

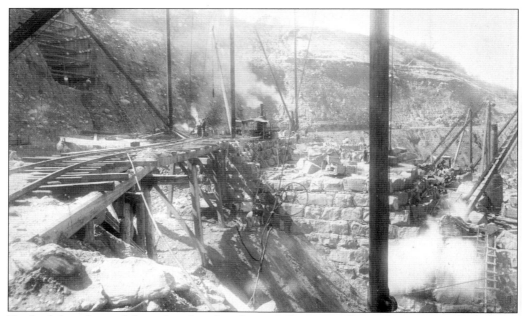

To the left and top of the railroad tracks, above, is the core wall trench. Dug into the hillside, the core wall was the continuation of the dam into the natural hillside. While technology was improving at the site, the core trench was still lined with simple boards and cross timbers, common in building in the Croton Valley going back two centuries. This design was used at the old dam and is blamed for its breach. The core wall concept was changed dramatically during the project and the masonry was extended at great monetary cost.

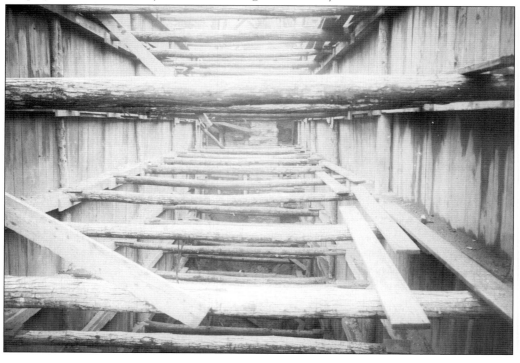

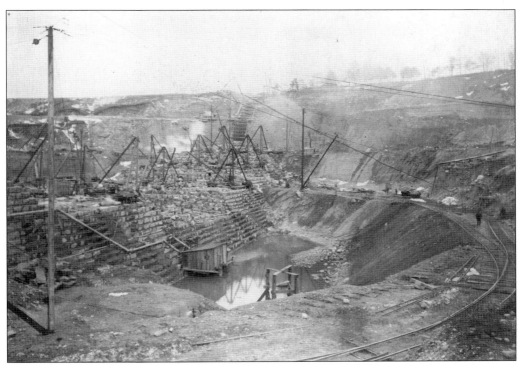

As the base of the dam took shape, erosion continued to wreak havoc on the project, as is clearly shown by the railroad tracks hanging precariously close to the edge of the fresh dirt, above on the right. December snows had an effect on the project, but the pace did not slow, as evidenced by the frenetic work scene below.

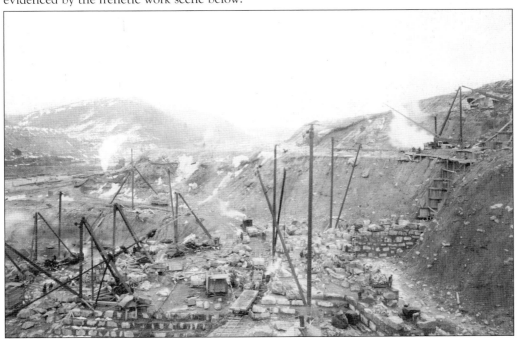

The rock bottom of the excavation site extended into the core trench dug into the hillside on the south side of the dam. Large timbers were used to hold the core walls in place (above), allowing the masons to begin laying stones. As the dam rose from the valley floor, the magnitude of the project became evident (below), with overhead cables used to send cartloads of stones out to the masons.

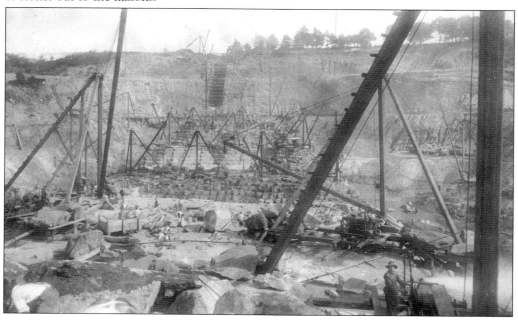

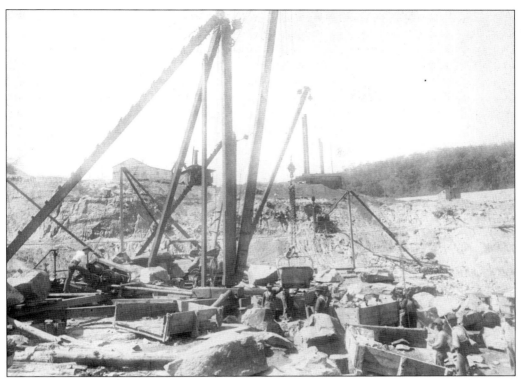

Since the stones each weighed as much as 3,500 pounds, railcars were required to haul them within striking distance of derricks, which then moved them onto the masonry structure for placement. With mostly wooden derricks and wooden carts hauling piles of stone in and rubble out, accidents did occur.

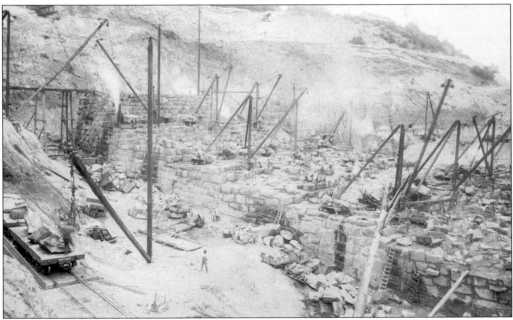

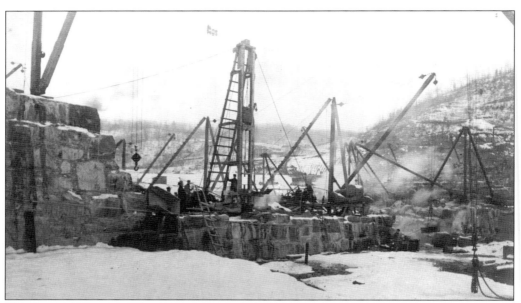

The year 1899 began cold and snowy in the hills of northern Westchester County. The masons and engineers alike suffered the effects of the cold (above), as they attempted to seal the masonry work on the foundation of the dam, using a clay driver. On the south side of the dam (below), workers were beginning the arduous process of backfilling the big hole along the extensions, or wings, near the now popular aqueduct trail. As these jobs moved forward, the incredible task of building up began in earnest.

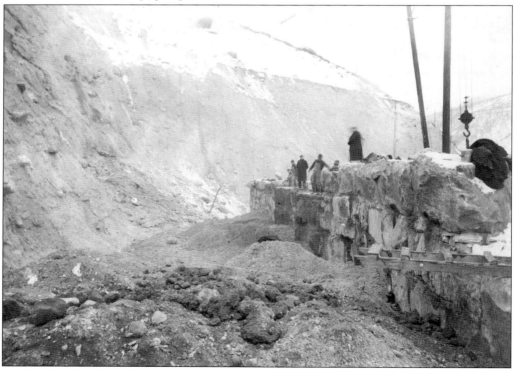

Four

BUILDING THE NEW CROTON DAM

At the dawn of a new century, the New Croton Dam was halfway through its almost 12-year construction cycle from clearing to completion. There was optimism and apprehension about what lay ahead in a rapidly changing American landscape, but those broad national issues were subjugated to the pressing need of New York City—and the engineers in the tiny hamlet of Croton—to finish the dam and aqueduct.

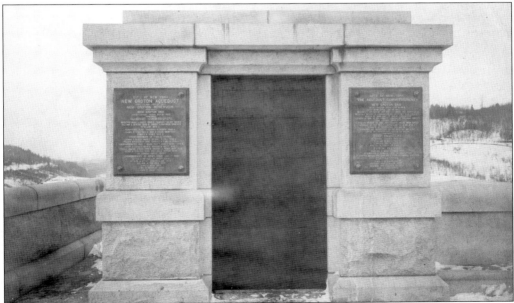

For New Yorkers, the most important concern in 1900 was gaining access to greater amounts of clean water. The Guard Wall Head House (the final piece of the grand masonry puzzle covered in this chapter) holds the tablets pronouncing the conclusion of this awesome project.

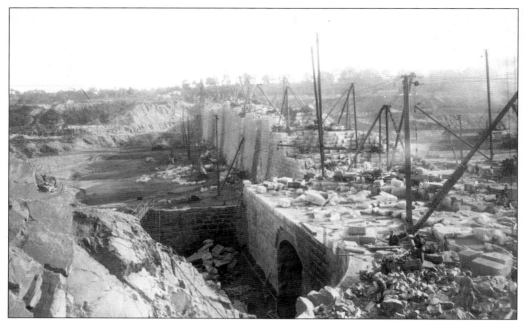

As the visible portion of the New Croton Dam rose above the base, the big hole was backfilled, creating a staging area for the trains to drop masonry to be lifted high atop the rising structure. Below, note the stones at the base of the dam that resemble sugar cubes but generally weighed from 2,500 to 3,500 pounds. Above and below, the retaining wall for the riverbed is evident, with the spillway extension rising with the dam. During construction, the Croton River flowed through a tunnel at the base of the spillway. Several times during the final years of construction, the tunnel could not handle the floodwaters of the river, which in turn overflowed the retaining wall and even flowed through the railway tunnel in the main dam.

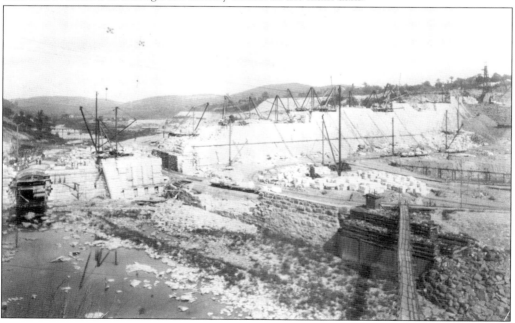

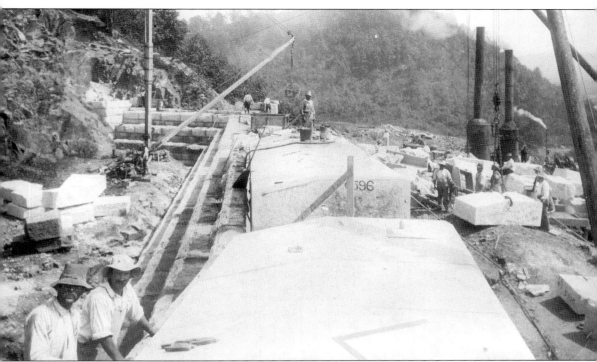

The far end of the spillway was only a few feet from the rock bottom of the hillside but 200 feet up from the base of the dam. The stonemasons are enduring the heat of an August day with felt hats to shade their faces from the sun as they move the coping stones, or cap, into place. Note the numbers used to identify the stones and their proper location. To the right, below the steam boilers used to operate derricks, masons prepare to lift a coping stone into place. Unseen above the spillway was a rail line used to bring the stones to the spillway directly from the quarry.

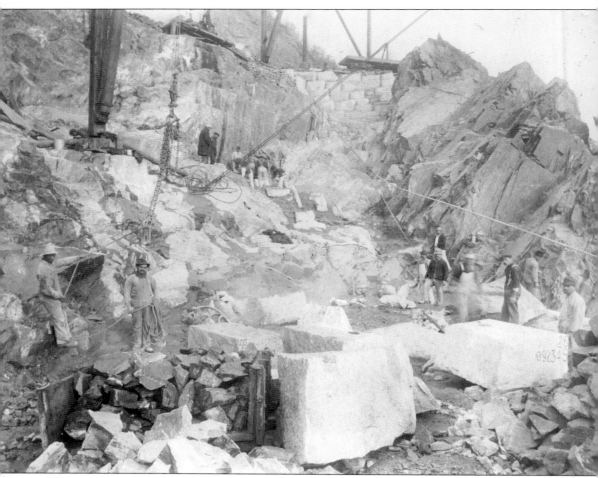

The spillway gorge of the New Croton Dam is well known for its jagged rocks and the thunderous roar that emanates during times of high water. This view shows the foundation of the spillway as the first stones are lowered onto the rock bottom. Note the smaller stones, or rubble, being hauled out of the area. Above the rubble cart are two men working with the derrick and pulley system. The worker on the left holding the rope above and in front of himself is probably African American. Tradition and records generally conclude the majority of workers at the dam site were Italian and Irish laborers. Many ethnic groups were present, however, including African Americans who, following the conclusion of the Civil War, arrived in Peekskill where they worked at the many foundries in the area. Other ethnic groups at the dam were represented by Chinese, Swedish, Polish, and German workers.

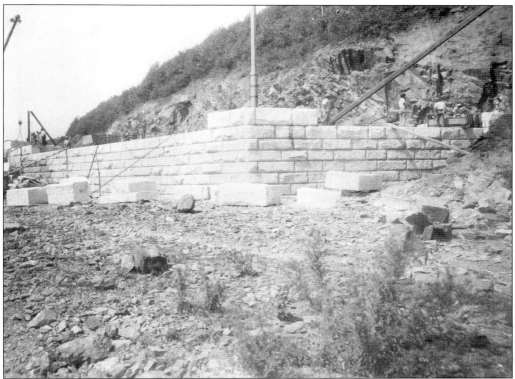

As the 1,000-foot-long spillway took shape, workers were dwarfed by the sheer size of the stones and the height of the steps, or tiers. The "angle" (above) is the point at which the spillway turns to connect with the rock face. This end of the spillway does not have much depth, but (below) the rock bottom falls away from the masonry rapidly, descending into the gorge below. Note the men in top hats and suits, posing with the masons during an inspection of the project.

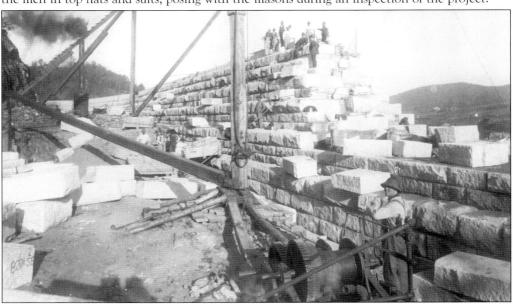

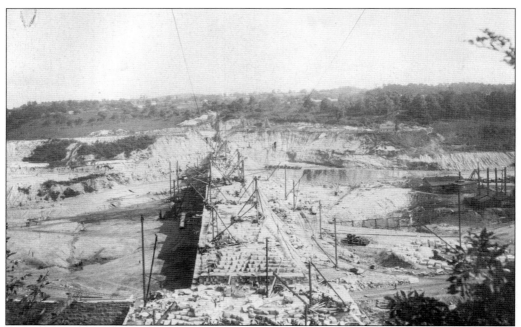

These photographs, both taken on August 22, 1900, offer views of the entire project on the same day. The photographs were taken in quick succession because the ten-car train with rubble sits on the siding in both. The big hole is mostly a memory of mud, but the erosion on the far hillside (above) remains a problem. Looking toward the spillway (below), the corner referenced in previous photographs is on the far rock embankment and offers a perspective of the magnitude of the project. Note the fill behind the wing wall in the lower right corner, which is now only feet from the height of the masonry.

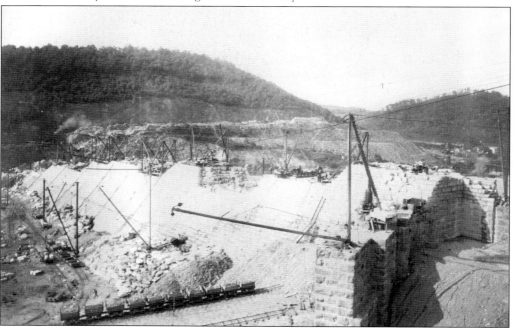

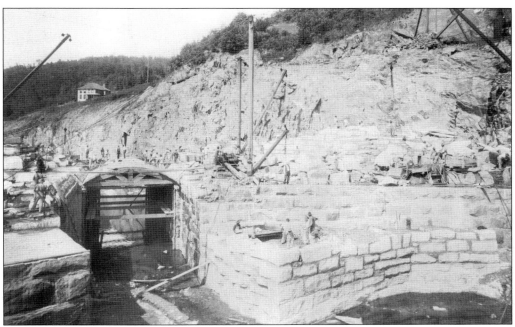

Periodically, engineers would make revisions to the plans for the dam based upon new calculations or upon their observations at the site. The river tunnel under the rising spillway is one such example, with new masonry construction built to withstand more force from floods than anticipated. The arched design of the ceiling of the tunnel is similar to that of the aqueduct tunnels. Below, the railway tunnel at the base of the dam was well above the expected high-water mark and the retaining wall from the riverbed. These precautions could not stop the Croton River in all its fury, as the destroyed railroad tracks indicate.

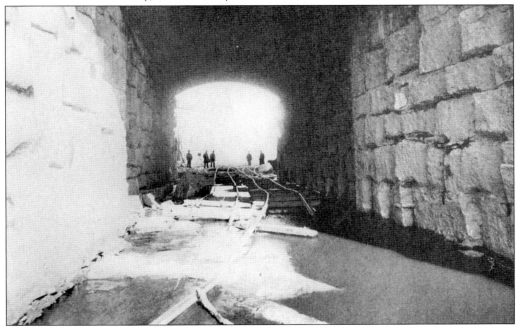

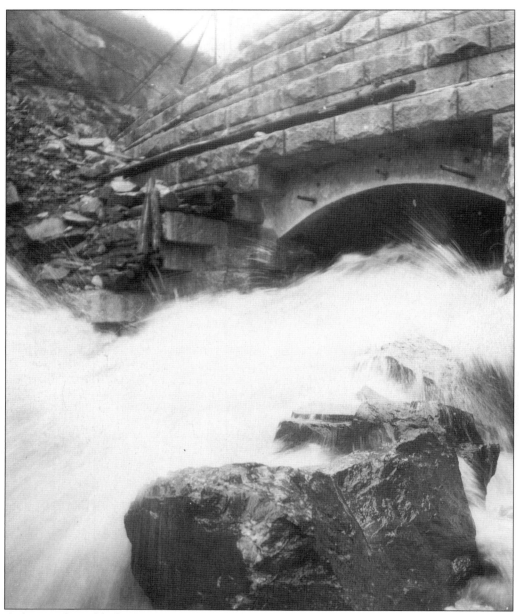

As history foretold, the Croton River periodically flooded. Despite the old Croton Dam several miles upstream, the lower river still became a raging torrent. March in Westchester County can bring heavy snow, rains, and snowmelt—all leading to floods such as this one in 1901. This tunnel is large enough for humans, horses, and carts to move through and it is nearly filled to the ceiling with Croton water. Despite such flooding, which damaged farms and bridges, the work on the dam continued unabated.

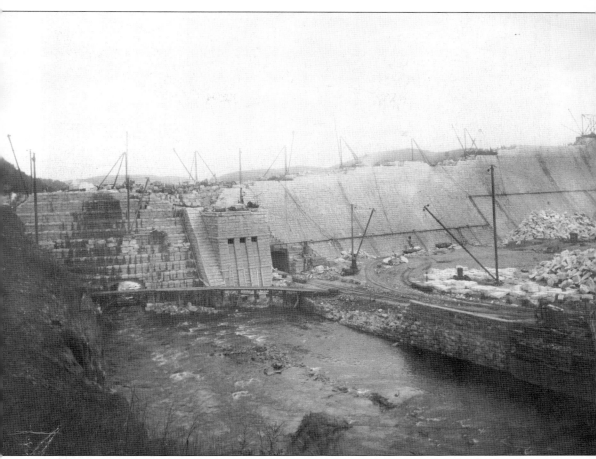

This final photograph of the dam in 1901, taken from the construction office footbridge shown at the lower right, offers a full view of the structure with nearly five years left until completion. The base or foundation is now nearly 100 feet below the surface of the fill. The retaining wall has been partially removed to allow a rail line to extend to the base of the spillway. The dark line running across the face of the dam is a walkway on which workers can move to adjust the lines and pulleys needed to shift the stones from the heaps shown on the right. The large squared structure protruding from the dam with three dark holes is the relief blowoff used to drain the lake for potential repairs and to relieve pressure from behind the dam.

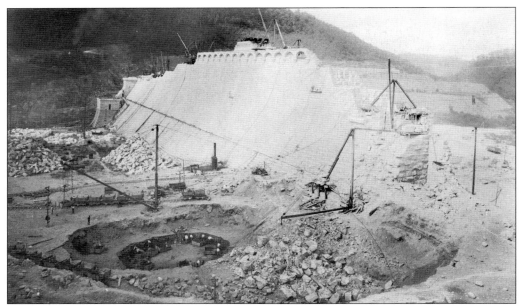

In September 1902, the face of the dam took on an increasing air of completion. In the above photograph, the highest point in the center eventually held the driveway, or road, and the decorative cornices later extended most of the length of the dam. The fact that they did not extend the full length of the dam was a result of the aforementioned design changes undertaken to make the dam more structurally sound. At an enormous cost to the City of New York, but for the safety of the dam, the masonry structure, rather than the original core wall and earthen embankment, was extended by 60 to 70 feet. The work at the base of the dam is the excavation of the earth and rubble to prepare the area for the extension of the masonry and the wings. In the photograph below, the rear of the dam has a sheer face built to take the full weight of the impounded water behind it. Despite the date in late summer, a pool of standing water has collected rather close to the masonry, once again offering evidence of the natural hazards of the river.

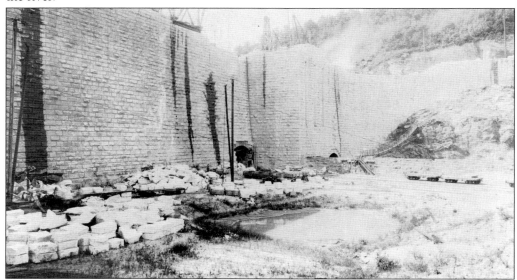

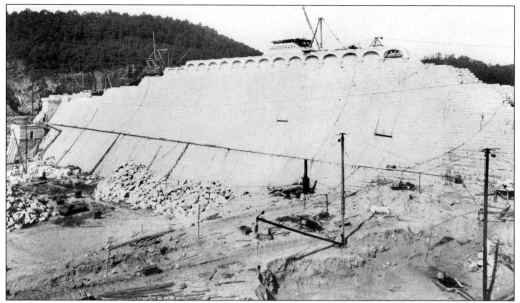

The downstream side, or face, of the New Croton Dam was coming into full view, as the summer of 1902 wound down. Cornices extend across nearly a quarter of the dam, and rail beds are slowly being covered by fill. Below, on the heights of the dam, workers have no more than 20 feet on which to work as many as 200 feet above the floor of the valley below. No safety harnesses are evident, and the scaffolding is far beneath them. Note the wooden ladders extending up the face of the dam for masons to climb.

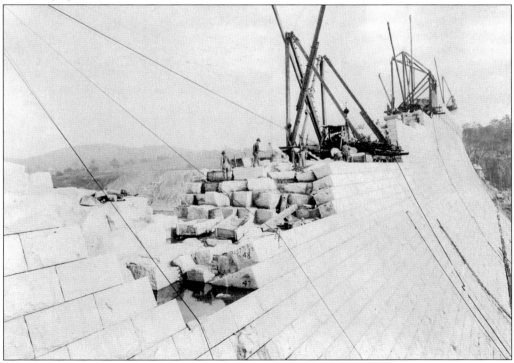

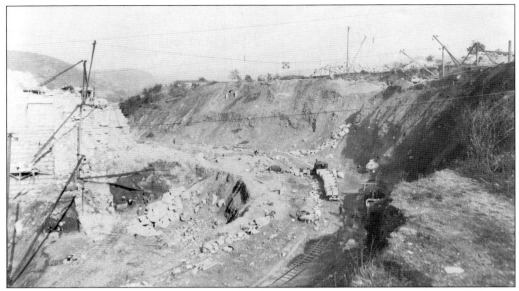

The steam shovel cut on the south side of the dam allowed steam engines with their freight to move from the front to the rear of the dam, giving derrick crews easier access to stones at higher levels than the downstream base of the dam. The tracks were regularly damaged by erosion and rockfalls. Below, erosion after autumn rains has buried a shovel and temporarily stopped work on the pick-and-shovel operation at the base of the upstream side of the dam.

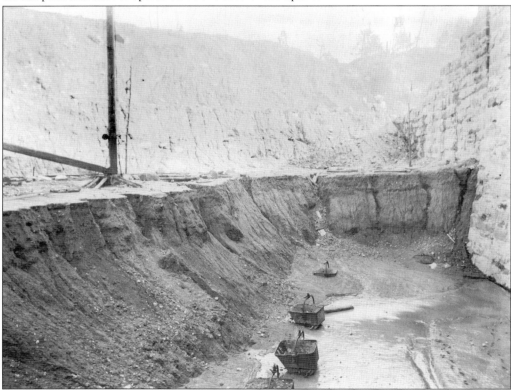

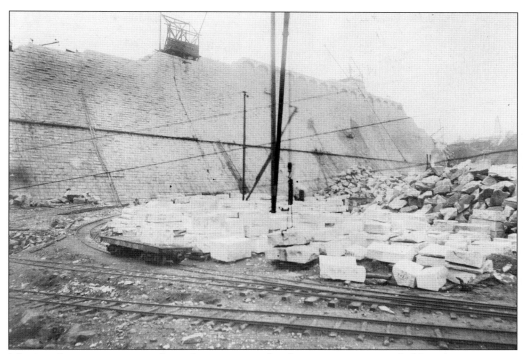

Moving the massive stones from the quarry to the dam site was a remarkable achievement in itself. The job of moving each stone to the ever higher structure of the dam, however, seems daunting in these 1902 views, with makeshift rail lines, flimsy wooden carts, and wooden derricks used to lift the pieces high above the workers below.

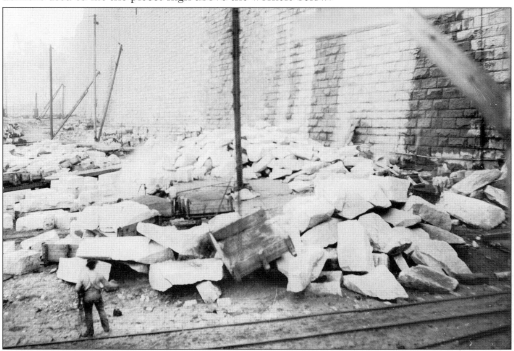

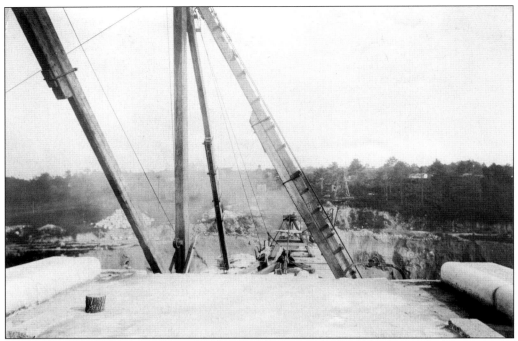

The wooden derricks protrude above this first section of deck, or driveway, at the top of the New Croton Dam. The derricks are lifting the hand-hewn pieces of masonry up nearly 200 feet to complete the upper sections of the dam. Below, a part of the extensive drainage tunnel that runs most of the length of the dam is shown. The tunnel also connected the two gatehouses on the top of the dam so that workers could move back and forth without venturing onto the deck.

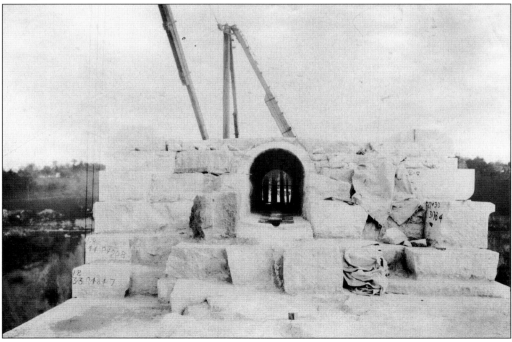

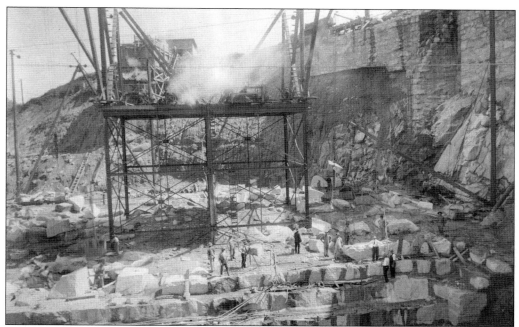

Despite the date in 1903, sections of the new dam still needed extensive work at the base. The high derrick is lifting a stone on the right and moving a shovel (blurred) on the lower left. The scene being played out amidst these heavy maneuvers is a survey for the newly engineered extension of the masonry dam, near where the intakes for the aqueduct were to sit eventually. Below, the preparation for the construction of the intakes and the completion of the design changes required the same level of effort as the rest of the project, with rails periodically changing location and rock slides affecting work.

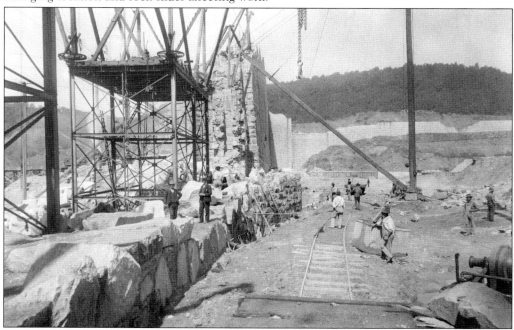

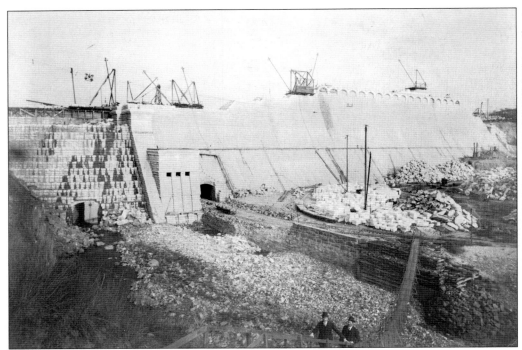

With 1903 drawing to a close, the spillway has risen almost even with the main structure of the dam. An engineer and an inspector cross the footbridge to the construction office, which commands a superior view of the downstream work in progress. For November, the Croton River is remarkably dry, but workers likely did not mind.

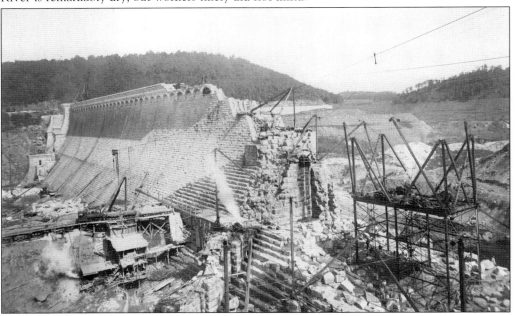

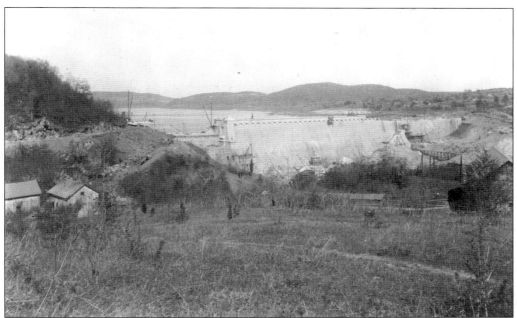

Seen here only six months after the previous photograph, the center portion of the dam has taken on a whole new appearance. Derricks have come down and most of the scaffolding has been shifted toward the continuing work on the completion of the extension of the dam. This photograph was taken from the location above the construction office known as "Black Mike's." The rising waters of the Croton River are an indication that the tunnel under the spillway has been closed, thus truly damming the river. While the view of the dam was serene, the far side shown above remained under heavy construction, with picks and shovels still used by the crews, seen at right taking a break for some nourishment.

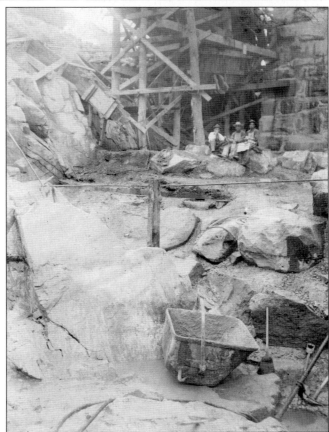

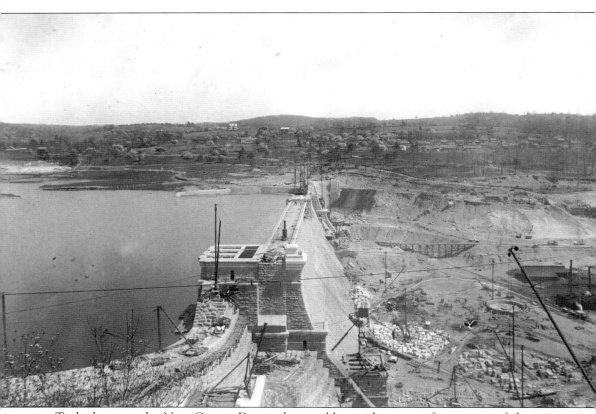

To look across the New Croton Dam today would provide a magnificent view of the green canopy that is northern Westchester County. The farms in the background are long gone; new homes have replaced the makeshift workers village to the right and above the dam. In this photograph, it is May 1905, and the waters of the Croton Reservoir have risen nearly to the top of the spillway. Below the downstream side is the construction site for the celebratory fountain that was to aerate the water before it flowed down the Croton River. It provided a popular spectacle for visitors.

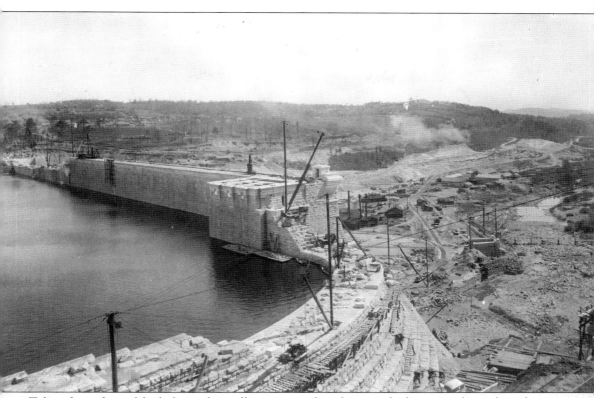

Taken from the rail bed above the spillway gorge, this photograph shows just how close the water was to the construction zone atop the dam. Floats can be seen to the right of the relief intakes, with men working. Rowboats are visible, offering mobility in the high water. Along the spillway, railroad tracks are evidence that stones were being hauled by train car directly on the masonry structure of the dam.

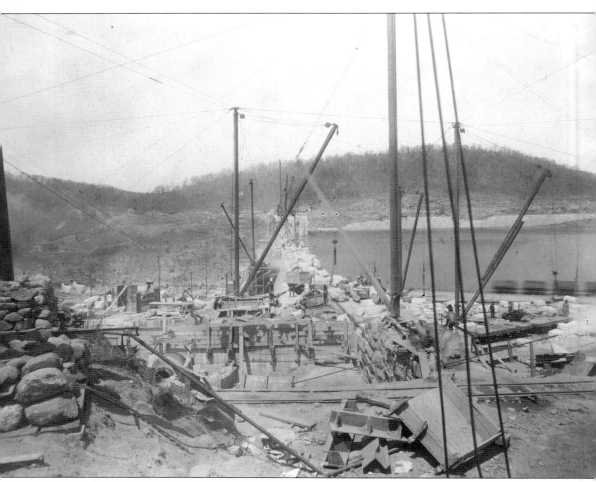

From the aqueduct side of the dam, a frenetic pace is evident; shovels and carts move by one another, and a train speeds rapidly out of sight on the right. It seems that a race is on with the water, as the engineers have allowed the reservoir to fill in order to begin testing the masonry.

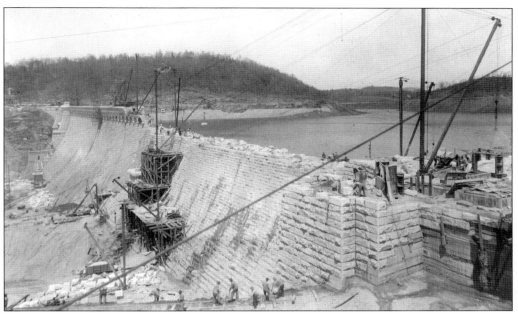

As workers began removing railroad tracks leading to the upper reaches of the dam, the enormous scaffolding in the center was still aiding in the efforts to bring stones to complete the top of the dam. The area in the foreground was later filled in up to the masonry line, evident on the right.

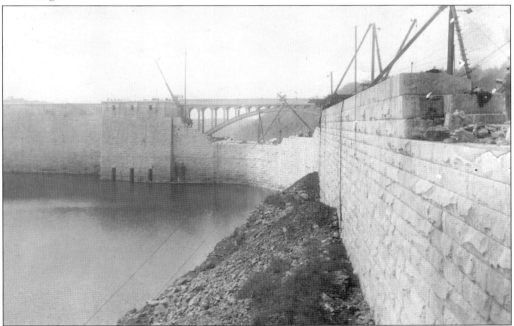

The year 1905 brought a new addition to the rising dam: the 200-foot arched bridge, for which the New Croton Dam was famous until its more modern replacement in 1975. The span was a graceful structure against the backdrop of the jagged gorge. Note that the water level has dropped, as the lake is drained off, using the relief gates seen at the left.

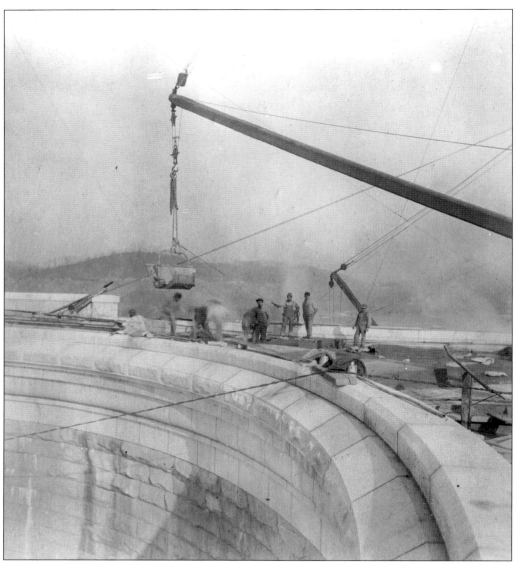

Just before Christmas of 1905, the final phases of heavy masonry work were being done on the aqueduct side of the dam. The crews are laying the concrete driveway after having completed the ornate edgings, which eventually held railings.

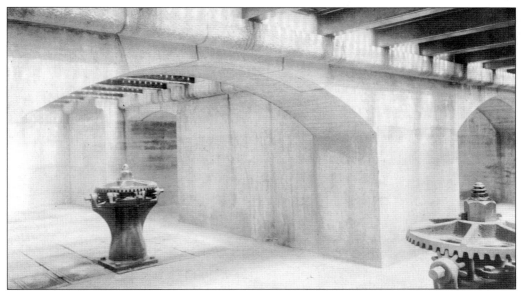

Photographs taken inside the dam are rather rare, since most of the interior was tunnel and very dark. These views show the gate chambers below the driveway and decks closest to the spillway and arch bridge. Above, the "screw pins" used to open the diversion gates appear in the natural light coming through small glass pegs mounted in holes in the decking. The photograph below offers a glimpse of the works with natural light because the driveway had not been laid at that point. These gates were used to send water from the new dam back toward the old dam via the original Croton Aqueduct or into the old aqueduct toward New York City. Most of the old aqueduct is no longer used today, but the section running back toward the old dam is still in use, allowing the city to tap what is often better quality water at the dam than at the gatehouse. The manual gates are long gone, and automated systems are now in place.

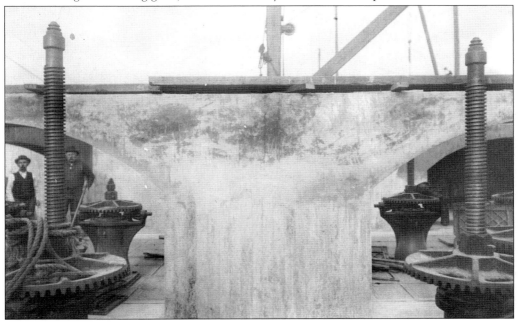

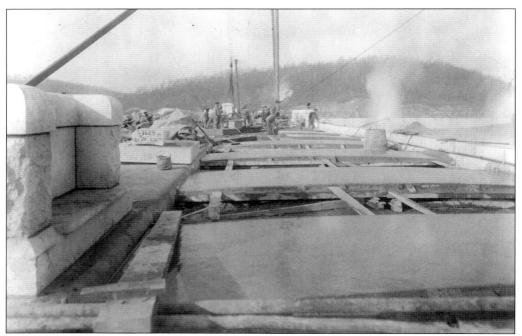

As the final sections of the driveway were completed, the area below the dam that later became a popular park was leveled and cleaned. The tiers used for rails were cleared of trackage and ties, and the slopes from the upper part of the dam were made smooth along the face. Note in the photograph below the lack of ornate molding on the south end of the main dam. This is the section that required changes in engineering. The cost and time overruns were enormous. Thus, some corners, such as ornamental molding, were cut. The final stone was laid in 1906.

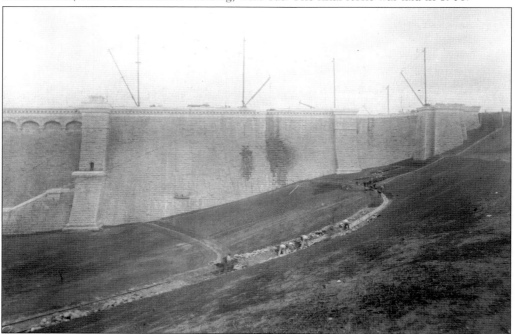

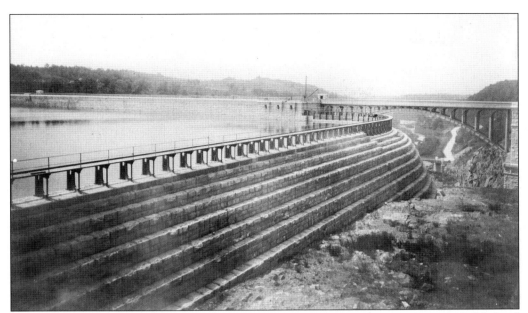

By June 1907, the dam was complete, with the waters of the Croton River impounded behind one of the largest masonry dams ever built. The bridging along the top of the spillway was installed to allow the New York Department of the Water Supply to raise the level of the reservoir by several feet during peak use. A small train hauled sections of wood that were then slid into place below the bridging along the full 1,000-foot length of the spillway. The bridging and several feet of the spillway were eventually removed due to concerns about pressure on the dam.

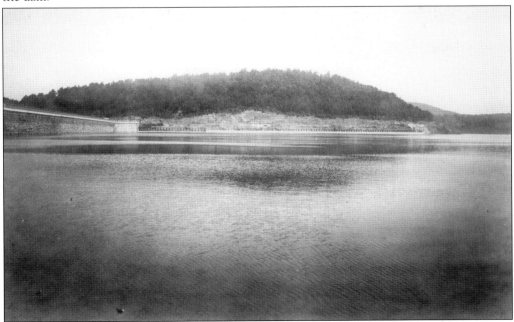

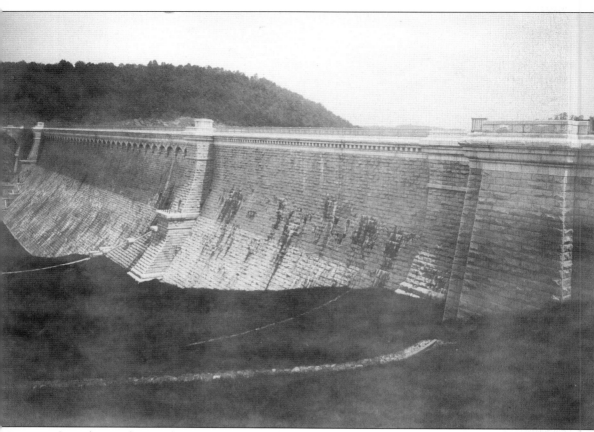

Complete with its railings and sculpted landscape below, the New Croton Dam, shown in this June 1907 photograph, is ready to impound nearly 34 billion gallons of water. The new aqueduct can siphon off water at the dam or at the gatehouse above the old dam. The total length of the dam in this state of completion is 2,400 feet.

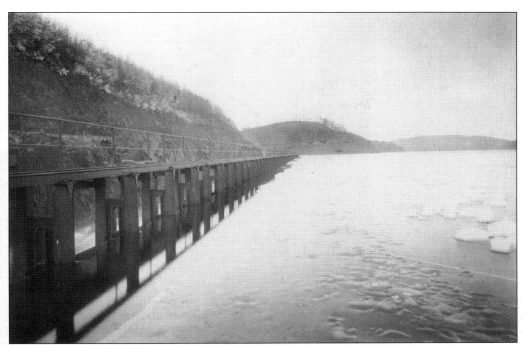

As with winters past, the Croton River Valley produced significant amounts of watershed into the reservoir. These two photographs indicate that even with severe cold and the formation of ice up to the spillway, serious overflow was still evident from the bridge. The height of water in this photograph has not been achieved since the railway bridge and several feet of the spillway were removed after a severe flood in the 1950s.

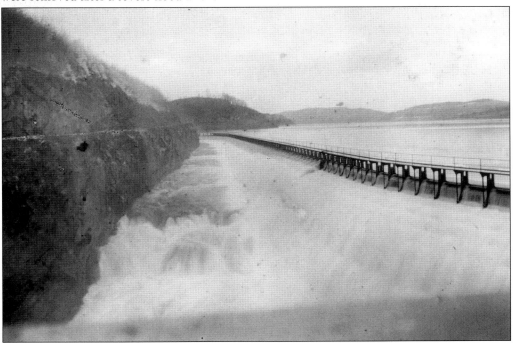

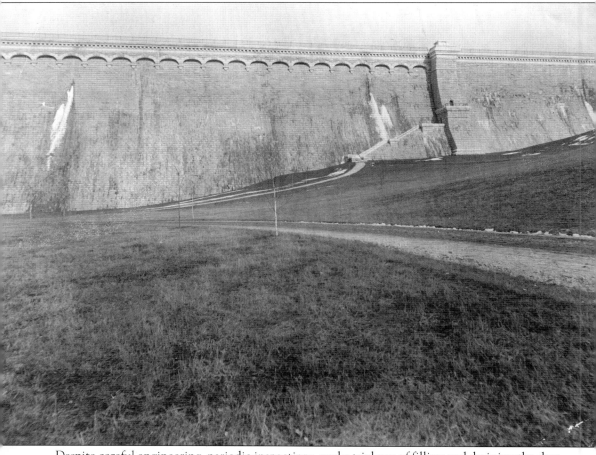

Despite careful engineering, periodic inspections, and a trial run of filling and draining the dam, temperature cracks appeared in February 1908. Although not serious, the cracks certainly caused some alarm below the dam.

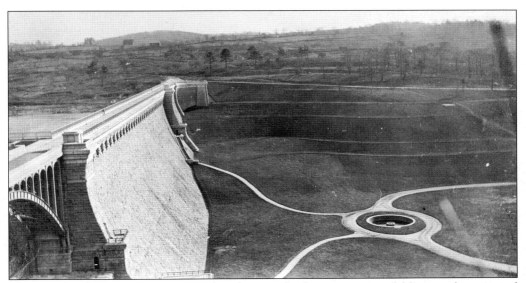

The completed Croton Dam was worthy of postcards, showing its graceful lines and manicured park below. The 200-foot span across the spillway still delights and instills fear in travelers to this day. More than one vehicle has plunged into the depths of the gorge from the roadway above. Several times over the Croton Dam's nearly one century of existence, people have also sought to end their lives by jumping from the driveway.

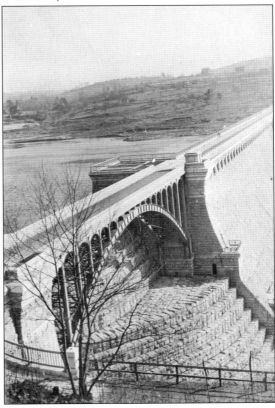

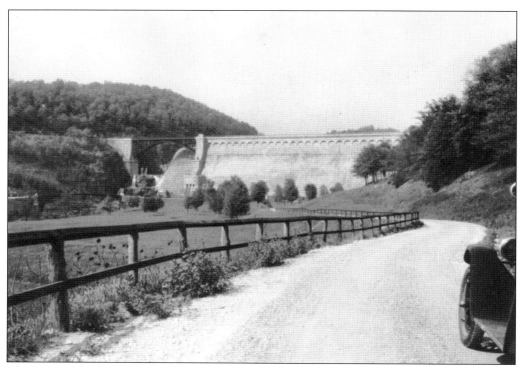

The bridge over the spillway was replaced in 1975 in preparation for the bicentennial. Because of concern for its structural integrity, the old span was replaced with a modern, simple bridge that has never caught the attention of dam aficionados as well as the old bridge did. Despite the loss of this beloved arched structure, people still flock to the dam to see the surrounding beauty or simply to look at the dam itself. The full view from the location of the early vehicle above is no longer possible due to the growth of trees.

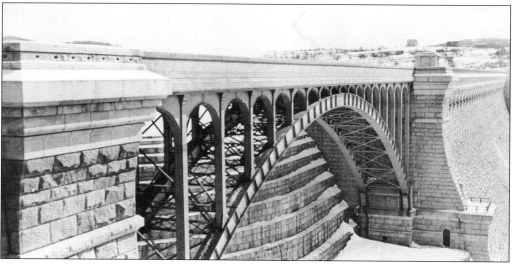

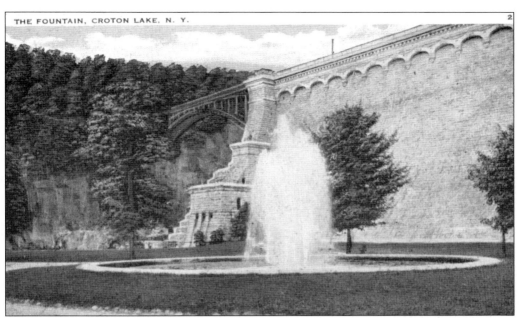

The New Croton Dam filled the valley behind it for more than 20 miles with the rising waters of the Croton River and its tributaries; it was no wonder that the area drew a flood of visitors. Weekenders and day-trippers crowded the park and driveway, just as they do today. The stories of the towns inundated by the waters, the squatters who refused to move, and the Mafia who robbed workers of their pay on payday were notorious to city and country people alike and attracted them to the area. The myths and legends of the Croton Dam project were many, and some grew into works of fiction, such as *Cassie's Village*, by Frances Riker Duncombe, a book about the inundation of the old village of Katonah, along the upper reaches of the Croton River. (Above postcard courtesy Chester and Elizabeth Tompkins.)

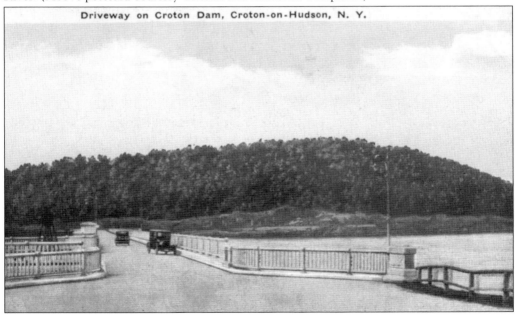

Driveway on Croton Dam, Croton-on-Hudson, N. Y.

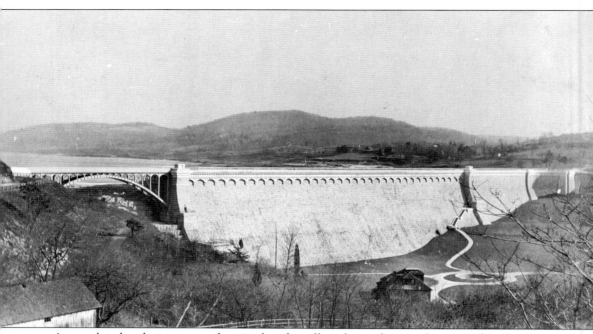

A completed and picturesque dam implies that all work was done in Croton and in the Croton Watershed. In reality, the people of the valley—those both old and new—were simply embarking on a new adventure. The New Croton Dam may have completed a process to bring a safe and plentiful supply of water to the ever-changing New York City, but it also brought dramatic changes to the valley whose water it impounded.

Five

A Changing
Landscape

In 1880, the Croton Valley below the old Croton Dam remained much as it had been since the first Europeans began tilling the soil in the 17th and 18th centuries. Once construction on the New Croton Dam began, however, the landscape rapidly changed with the confiscation of land, the construction of new highways and bridges and homes, and most notably, the disappearance of entire villages and communities.

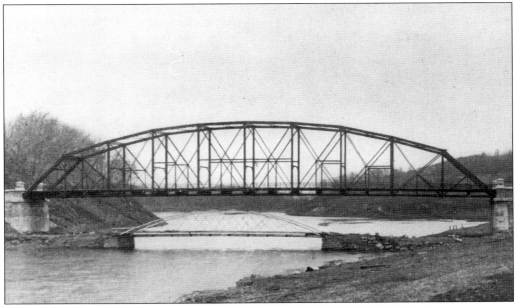

The juxtaposition of the old and the new Wood's Bridges, on the border between the towns of Somers and Bedford, near Cassie's Village of Katonah, offers the perfect contrast found in the Croton Valley, as the waters rose behind the new dams of the Croton System *c.* 1905.

Dixie Valley is mostly a forgotten name, except in the minds of a few remaining locals who spent their youth hunting in the deep woods that grew after the New Croton Dam was completed. The road out of the valley was typical of those in the area—dirt and generally impassable during the height of winter. The top photograph shows that the roads above the old Croton Dam were just as rustic as those below it. Despite the January 1905 thaw, the road in the foreground, below, is made impassable by the drifts of snow against the New England-style stone walls.

Looking up the old highway along the Croton River, the Palmer House, which was moved to save it from the rising waters, was visible along the new highway. Note the brand-new fencing along what today is N.Y. Route 129. The Palmer House eventually became the residence for the superintendent of the Croton Reservoir. After being abandoned and occupied by "draft dodgers" and "hippies" during the Vietnam era, the house was converted into a precinct for the Department of Water Supply Police. The Palmer House was one of many homes saved from the encroaching water of the reservoir. Teams of oxen were reportedly used to pull homes from existing foundations to new locations on high ground. Many old homes along Route 129 were at one time below the current level of the reservoir.

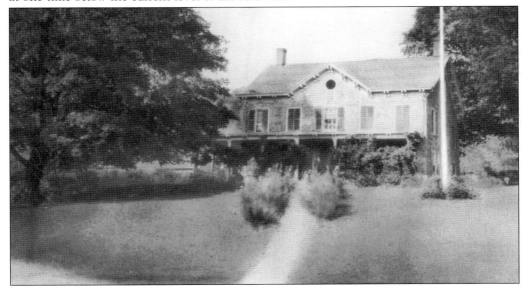

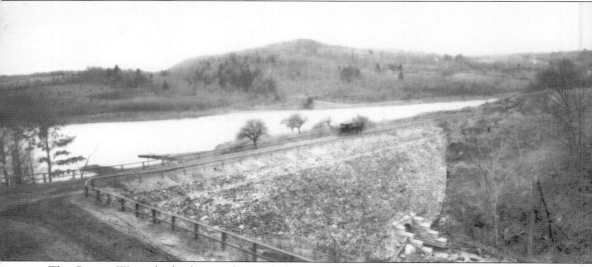

The Croton Watershed is known for its plethora of brooks and steep hollows. All such streams had to be forded by the new highways constructed to raise roads above the water level of the new reservoir. The intersection of what is now N.Y. Routes 118 and 129 looks serene without the flow of vehicles and the blinking traffic lights of today. Route 118 stretches from Baldwin Place through Yorktown to Pines Bridge, following the Sawmill River, a brook flowing out of Yorktown Heights, to the Croton Reservoir. Route 129 is a short highway connecting Route 118 from this intersection with Croton-on-Hudson by following the banks of the Croton Reservoir. Known for its beautiful fall scenery today, the route is well used by commuters heading to New York City via the Hudson Line of the Metro-North Railroad. Needless to say, both routes are busier now than they were for the driver of the horse and buggy, visible in the center of the above photograph.

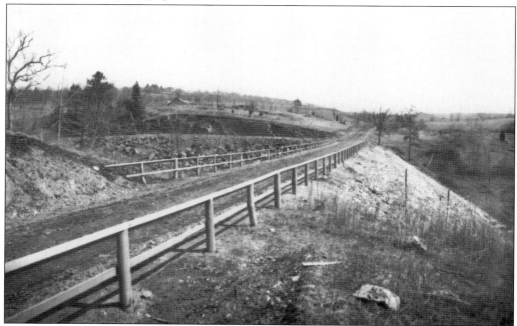

The stark contrast of these photographs marks the change from a strictly rural community to the engineering and design consistency found in all of the new bridges along the Croton System. While most of the bridges seen in these photographs were replaced in the 1980s, the bridge below the New Croton Dam, leading into what is now a Westchester County Park, remains intact. Note the masonry that was once found on all watershed bridges. Above is a 1905 photograph along the Hunter's Brook, with the Ackerman farm at center, a long-forgotten site in affluent Westchester.

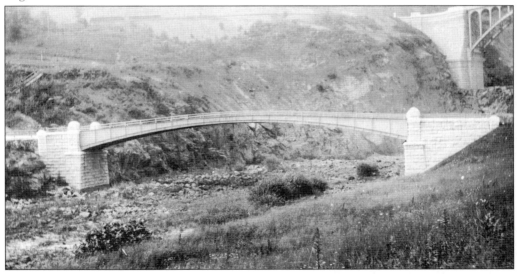

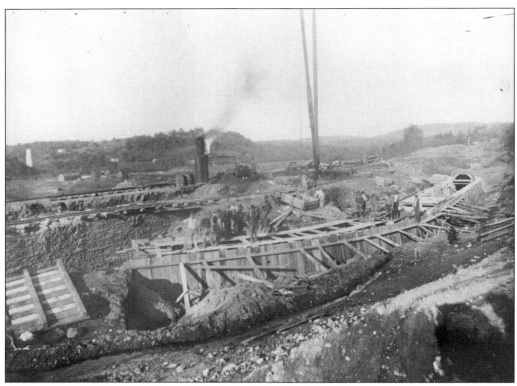

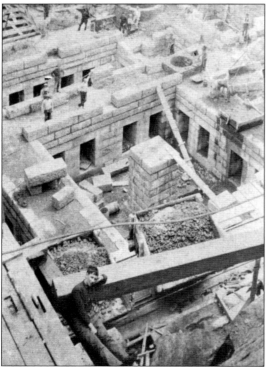

As the graceful curves of bridges and new highways were under construction in the valley, so too were the major engineering feats of building a tunnel from the dam site back to the gatehouse at the location of the original dam. Water could be siphoned off at the gatehouse (mid-reservoir) or at the dam. It then ran through tunnels constructed of bricks and mortar to New York City. The photograph above is a view looking from the south shore of the Croton Lake at its widest point across to the mouth of the Hunter's Brook Valley. Note the masonry bridge abutment jutting out of the background. At left is the cavernous project of building the gatehouse to control the flow of water from Yorktown to New York City.

Stonemasons were employed throughout the Croton Valley, not just at the dam site. This masonry pier is for the Route 129 bridge over the Hunter's Brook at the Yorktown-Cortlandt line. This is traditionally held to be the deepest part of the reservoir today, and the height of the piers indicate that this is accurate. Note the rail line used to bring the stones in and the overhead pulley system used to carry stones across to the opposite hillside. The decorative stonework atop the pier is now used as the decorative entry to Bridge Pointe, a nearby subdivision.

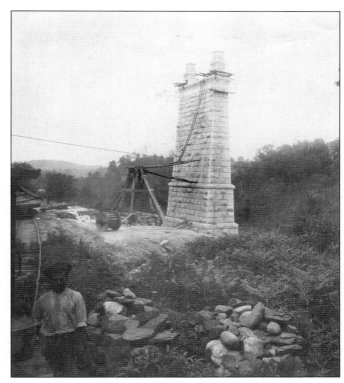

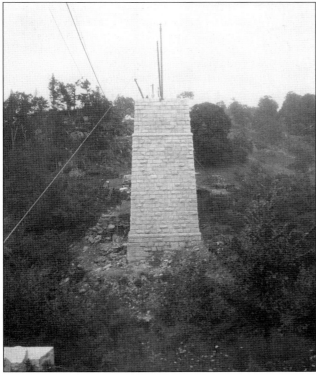

The mouth of the Hunter's Brook Valley was so steep that it remained heavily wooded at a time when surrounding land was under plow or hoof. All stones for the towering pier were swung across the gully along the overhead guide wires.

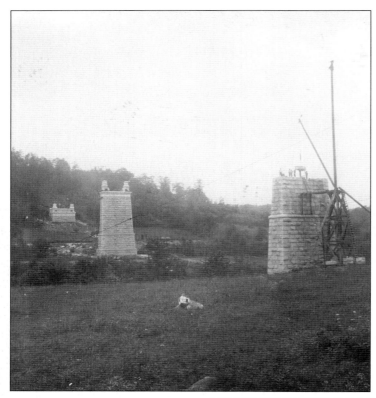

With the abutment in the background and piers nearing completion in 1901, the deck and superstructure were yet to come. The child in the foreground is likely the photographer's. Note the masons moving a stone into place after it was sent across the 200-foot valley below on a pulley. The earliest known motor vehicle fatality in Yorktown occurred in the years after the bridge opened at the far abutment, which required a 90-degree turn to enter or leave the bridge. Accounts at the time referred to the driver's death while driving a "horseless carriage."

The high derrick on pier 1 of the Hunter's Brook Bridge was the highest on any bridge in the system. Note the photography equipment in the foreground. Deep in the background is one of the stone quarries used for the construction of bridges along the Croton River. Even today, this view remains mostly rural, with land above the Hunter's Brook inlet devoid of the heavy development that overtook the rest of Yorktown and Cortlandt. The old hamlet of Huntersville is one of the most sought after sections of Yorktown and Cortlandt, not to mention all of Westchester County. The original Pepperidge Farm man lived in the area along with many well-known but private people, including composers, great legal minds, and founders of famous American corporations.

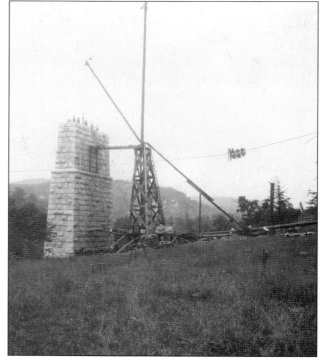

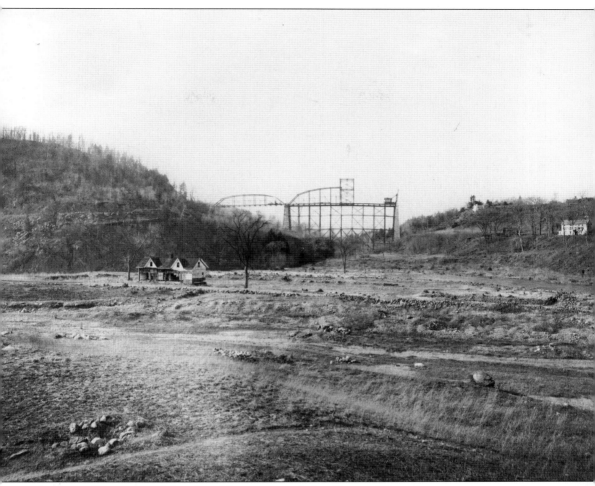

As the valley prepared for the rising waters of the Croton River, houses were moved or abandoned, as was the Tompkins Farm at the confluence of the Hunter's Brook and the Croton River. The abandonment of the farm concluded a chapter in river history dating back to 1751, when John Tompkins of East Chester purchased land from Pierre Van Cortlandt. By 1820, the Tompkins family owned the most land in Yorktown—more than 1,500 acres. Above the farm in this photograph, the new face of the valley nears completion, as the deck and superstructure move toward the eastern side of the valley. To this day, the Hunter's Brook (now the Hunterbrook Stream) continues to support a native trout population, despite the fact that it runs through densely populated areas of Yorktown, along the Taconic State Parkway and the Bear Mountain Parkway Spur near U.S. Route 202.

Although New England is touted as home to the oldest covered bridges in America, much of the eastern side of the Hudson River had them as well. The Wire Mill Bridge, above, had only a short time until it was replaced by the Hunter's Brook Bridge, visible in the background of this winter of 1905 photograph. The waters of the Croton River were on the rise and were within inches of the deck. The photograph below shows the demise of the bridge that once connected the central Croton Valley with the east side of the Hunter's Brook and Northern Yorktown. Many of the planks had been removed, but most of the bridge was simply burned.

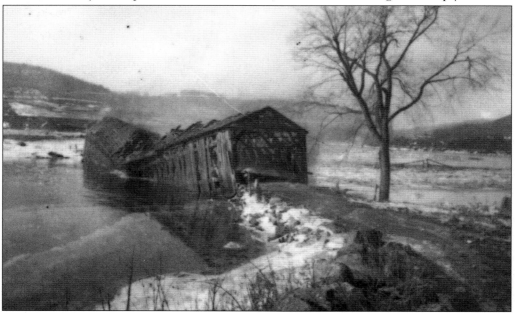

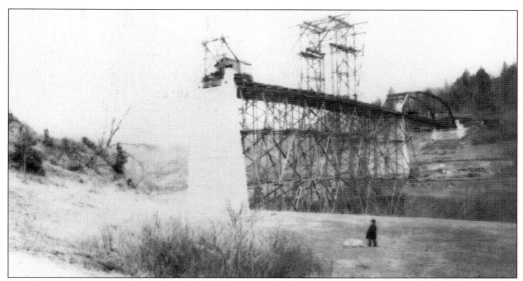

Standing in what is now a favorite fishing cove below Hunterbrook Road (note the current spelling), the engineer above observes the progress of the Hunter's Brook Bridge from the east side of the project. The work crews on the bridge were said to follow the Catholic tradition of crossing themselves before heading over the span. Similar actions were taken by engineers of the quarry trains that rumbled through the upper Hunter Brook Valley and crossed multiple high trestles in the remote hollows leading to the stone quarry beyond Dixie Hill. Construction of the 200-foot arch bridge across the spillway of the dam was in full progress in 1905, just as it was on the other bridges in the valley. The Baltimore Bridge Company provided the steel. Note the amount of fill that was brought in to provide stability to the scaffolding (below).

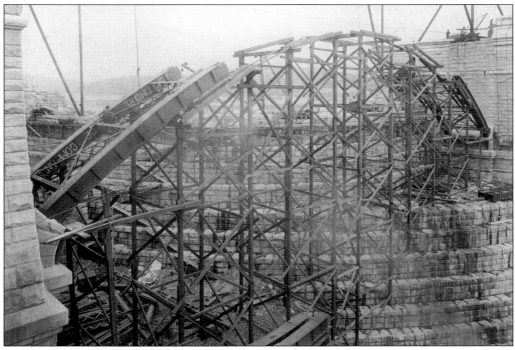

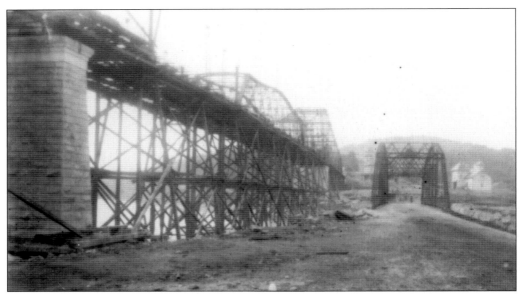

The Pines Bridge has been a part of the Croton River Valley since the earliest settlers arrived in the region. Since colonial times, it has connected points south toward New York City to points north into Somers and into the Harlem Valley. This was the point where British soldiers crossed and massacred troops at the Davenport House in Yorktown, and also where Maj. John André crossed just before being captured as a spy working for Gen. Benedict Arnold. The buildings in the background, above, are long gone but once included a guest house and eventually a restaurant. The note on the reverse of the postcard below may have referenced the guest house where the writer was spending a few days and having a "good time." The postmark from 1918 was from Croton Lake, a flag stop on the Putnam Division (the long-defunct "Old Put") of the New York Central Railroad.

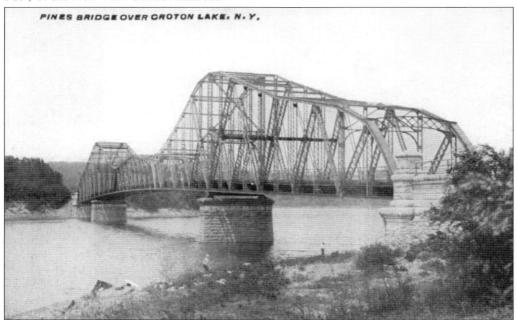

PINES BRIDGE OVER CROTON LAKE, N. Y.

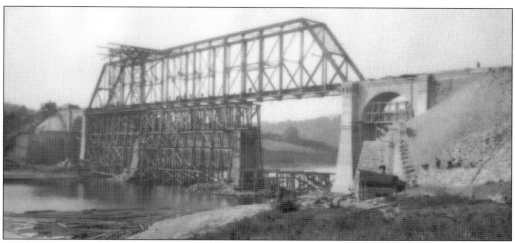

The Putnam Division of the New York Central Railroad, like many other railroads in the United States, had various owners throughout its history. At the time the New Croton Dam was being built, the New York and Northern Railroad owned and operated the right-of-way. Trains hauled material to the upper part of the Croton Valley for work on the aqueduct and continued hauling milk from area farms into the city. The new reservoir, however, changed several things for the railroad. A new bridge (above) and higher grade levels between Yorktown Heights—midway to Brewster—and Kitchawan Station (below) were required. The new trestle over the Croton River restricted the weight of engines and was a sign of the end of the milk runs, as dairy farms disappeared beneath the river and refrigerator cars hauled milk from farther afield. The bridge abutments (below) join the newly elevated N.Y. Route 134 connecting Ossining with Mount Kisco along the south side of the Croton River.

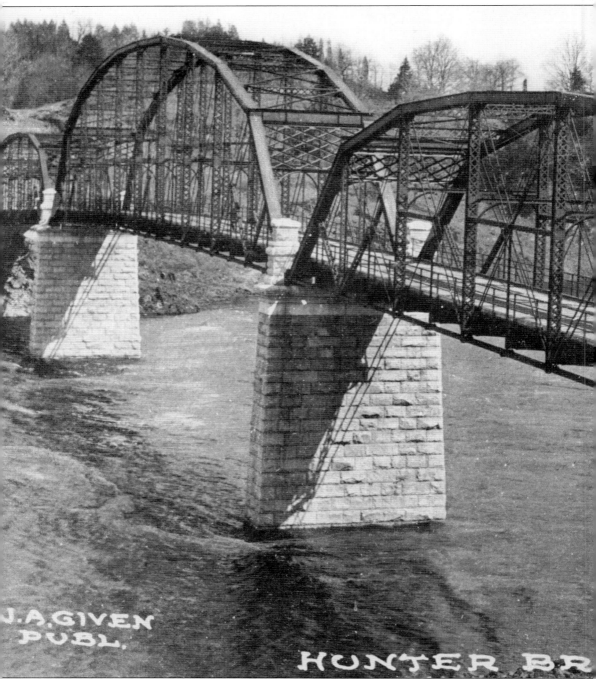

J.A. GIVEN PUBL.

HUNTER BR

The final product of the Hunter Brook Bridge was an engineering feat. With as much as 200 feet to the bottom of the valley below, it spanned the deepest part of the lake and offered a view of its widest point. The bridge crossed what was once a thriving community, Huntersville, which had its own church, school, mercantile, and wire mill. Today, the Hunter Brook Bridge is a flattop, curving away from the treacherous abutment of the old bridge that was feared by

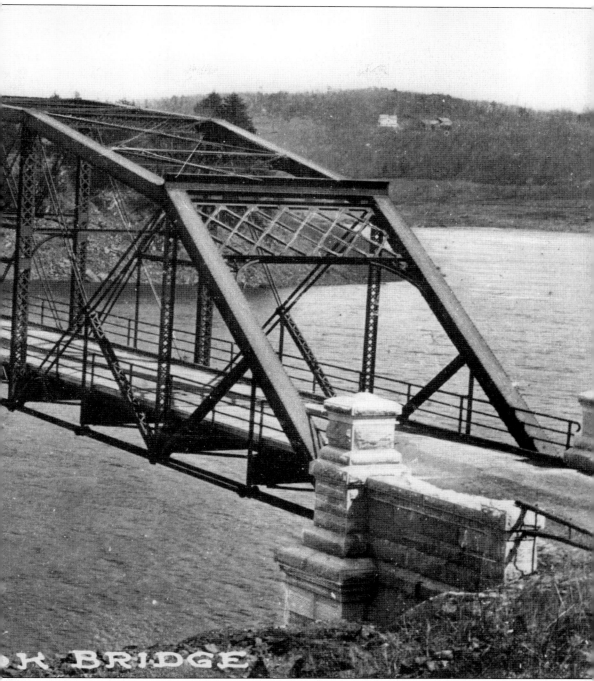

K BRIDGE

many. This photograph marks the first known use of Hunter, as opposed to the possessive Hunter's, which referred to the Hunter family for whom the community and brook were named. Remnants of this once thriving community can still be seen along Hunter Brook Road. Aging mill ruins and the overgrown cemetery at the Community Church of Yorktown on Baptist Church Road are reminders of that pre-dam community.

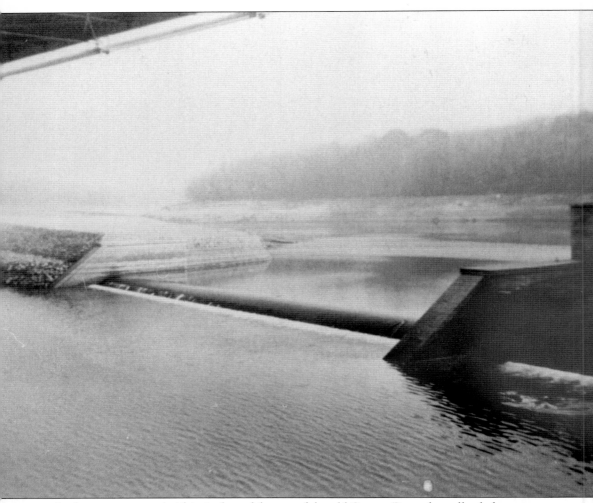

As the waters rose to within inches of the top of the old Croton Dam, the valley below was gone but to the minds of those who once called the valley home. For generations, the Croton River had fed the fertile valley with its constant and clean water. Families passed land on from generation to generation and attended churches founded before the American Revolution. The 34 billion gallons of water impounded by the New Croton Dam nourished the people of New York City but changed the lives and faces of northern Westchester County forever.

Six

NEW AND OLD FACES

When the first surveyors for the new dam arrived along the Croton River in the 1870s, the surnames of local inhabitants read like the first census of the United States. Most of these families remained a part of the landscape, as new names from Italy, Ireland, and across eastern and southern Europe were added to the rolls.

Religion was a focal point of the communities of the Croton Valley. Churches, established as early as the 1740s, continued to thrive into the 1900s, while new churches sprang up in the Irish and Italian Catholic traditions, as well as other Protestant sects. This post-World War II photograph includes members of old families—Wilson, Parent, and Tompkins—and new families—Young, Neihammer, and Leach.

The Bowery—derived from the Dutch word for farm or country seat—is most often associated with the overflowing tenement buildings on the street and area of the same name in lower Manhattan in the late 19th and early 20th centuries. The *c.* 1905 photograph at left shows the Bowery at Croton Dam. By 1905, Croton Dam had become a place-name with cheap rooming houses, bordellos, saloons, and plenty of crime. Italian and Irish immigrants, among many other job seekers, called the Bowery home and enjoyed or tolerated its many vices. However, the two ethnic groups lived in separate areas in a tradition that continues in New York City's various ethnic neighborhoods today. Water below the Croton Bowery was likely not as fresh as that which traversed the aqueduct as drinking water from above the dam for the obvious reasons of laundry, bathing, and latrines. The 1897 photograph below was taken prior to design modifications that extended the masonry dam. It offers a glimpse of work in the enormous excavation. Traditionally, the masons at the dam were of Italian descent, but various ethnic groups had no choice but to work together to complete the project.

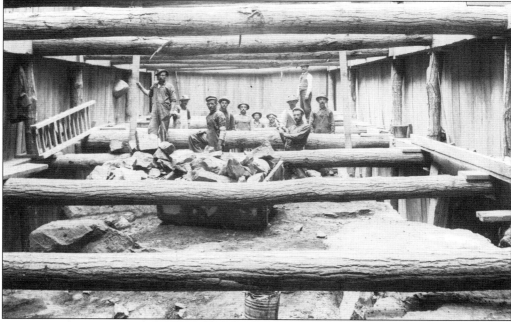

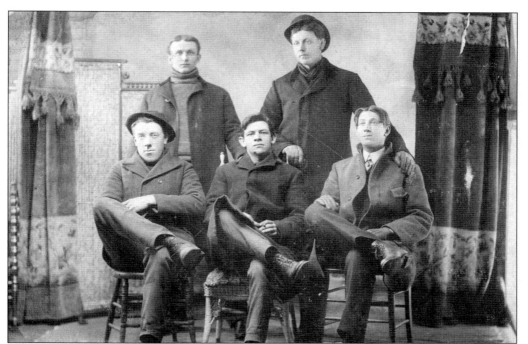

These 15-year-old students from Clinton High School in New Jersey learned of the project *c.* 1899 and sought work at Croton Dam. Robert Denison (seated at the right in the above photograph) was hired as a quarry train engineer at the New Croton Dam project two years later. When the contractors realized that he was under the age of 18, he was demoted to fireman until his 18th birthday. In the bottom photograph, Denison (standing at the left) poses at Westchester Creek *c.* 1904. Having gained experience and modest savings from the Croton job, he was prepared to create his own construction business soon after the new dam was completed.

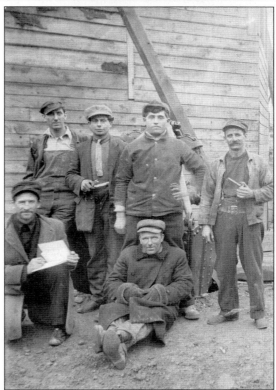

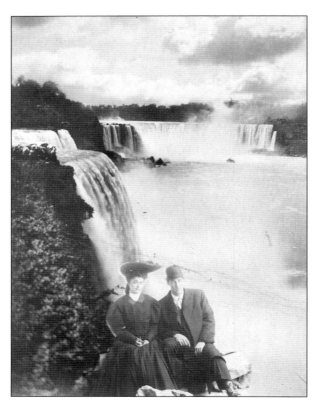

The New Croton Dam project spawned wealth at various levels of society. At left, a 20-year-old Robert Denison married Clara Ferguson and spent a honeymoon at Niagara Falls *c*. 1905. Confidence in the 1920s economy could not stem the horrible onslaught of recession and depression after the stock market crash of 1929. Denison did open his construction business but lost everything after 1929, including the steam shovel below, pictured possibly in the Bronx.

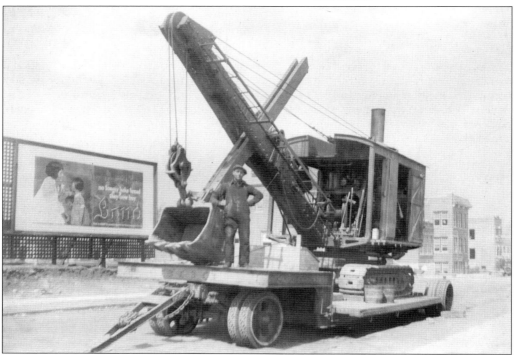

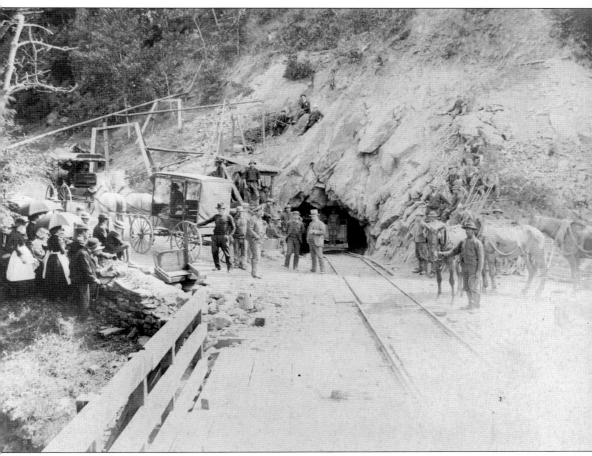

This photograph is purported to show a tunnel bore near the gatehouse in Yorktown. Several tunnels for the aqueduct were cut through solid stone at that location. Note the carriages, which brought the engineers and the dignitary with the top hat (near the tunnel) to the project. While the dignitary is unidentified, his arrival brought out spectators with bowlers, domestic uniforms, and even children. Everyone present took a moment to pose for the camera and, perhaps, for the unusual presence of women.

These wash women posing next to a mold for the aqueduct receive some rare attention from the camera. Most of their work was behind the scenes, often in the Bowery in the homes of local merchants or resident engineers. Note the relatively young age of the one second from the left.

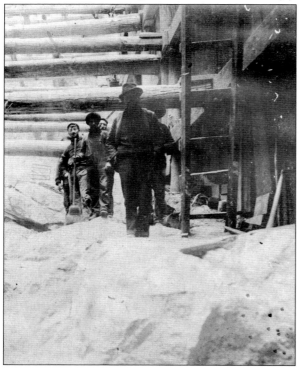

Inside the core wall of the dam, c. 1898, men from various ethnic and religious backgrounds are preparing the rock bottom for the impermeable wall, meant to keep a saturated embankment from breaching in particularly wet seasons. Three years after this photograph was taken, major revisions were made to the engineering plans for the dam. The rock bottom pictured here was thought unstable and the concept of a soil embankment extension was deemed too vulnerable, especially after considering the destruction of the old dam, which used the same concept. The masonry project was thus extended for the entire length of the dam.

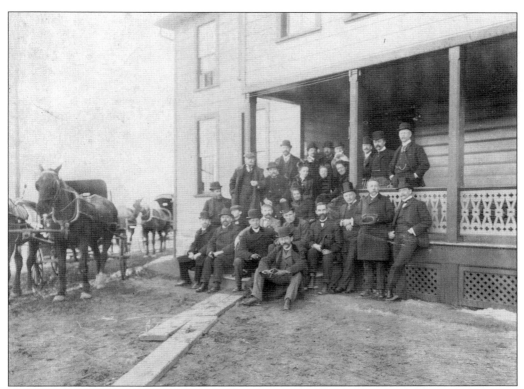

On January 20, 1899, men from the American Society of Civil Engineers arrived at the New Croton Dam construction site. They pose in front of the contractor's office, several of with cigars in hand. The boards laid before them indicate the January thaw and subsequent mud.

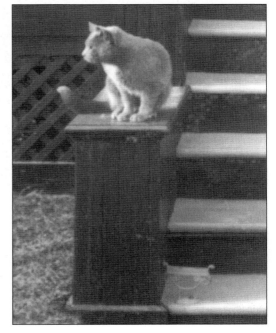

The resident cat on the steps of the engineer's office seems at home with all the noise, mud, and people. Based on the feline's presence, there was no shortage of mice and rats. Note the boot scrape on the lowest stair, used to clean mud off the boots of anyone going into the office.

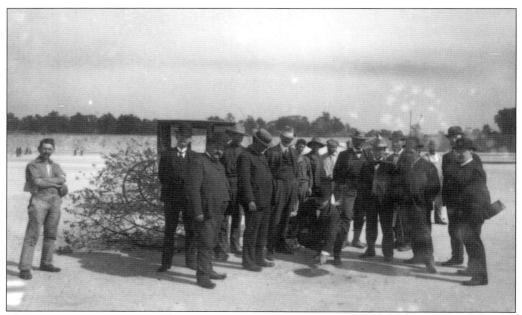

The American Society of Civil Engineers spent time in 1898 visiting several sites in the Croton Watershed. This view was taken on the lake bed, reported to be a reservoir near Brewster. The retaining walls in the background indicate that is may be one of the northern reservoirs above the Croton. The man pointing to the watery hole is likely Allophones Fettle, chief engineer of the New Croton Dam. Below, young men pose regally for the camera, pipe in hand (right). Note the lack of facial hair compared to the dignitaries above.

Although most photographs of a construction project show the men responsible for the project, it is the women behind the scenes that make much of the system work. This was the same on the farms in the valley. Most records imply that men were the only people at work in the mills and on the farms; such records offer only official glimpses of reality. This *c.* 1899 photograph shows Jennie Mitchell Tompkins, the wife of Gilbert Tompkins of Huntersville. She gave birth to her first child when the New Croton Dam project was just getting under way in 1896 and delivered her 12th child in 1919, long after her home had been inundated by water. Surely she did not find domestic life with so many children much easier than working on the dam.

Elias Quereau Tompkins, pictured *c.* 1890, was born in Huntersville *c.* 1800. He witnessed the Croton floods, the construction of the old Croton Dam, and the devastating dam break. During his 96-year life span, he watched as the population of the lower Croton Valley shifted to accommodate the Irish families who arrived to build the old dam. He was a primary benefactor to build a new Greek Revival-style Baptist church to replace an 18th-century meetinghouse. He lived to see the beginning of construction of the New Croton Dam but moved his family to a large Victorian home in the new center of town, Yorktown Heights, a station along what was then the New York, Westchester, and Putnam Railroad.

This photograph dating from *c.* 1959 shows the interior of what is known today as the Community Church. It depicts the building with few changes from its construction in the 1840s, except for the large gas heater hanging from the ceiling. Note the gas lamps to the left and flanking the pulpit. These are used today for the Candlelight Service on Christmas Eve, which has been held since the 1930s. Prior to the gas heaters, potbellied stoves were used, as indicated by the closed flu above the hymn board.

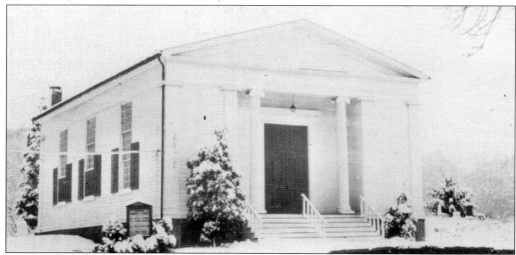

The exterior of the Community Church, pictured *c.* 1959, offers the visitor classical Greek lines and wintry scenes well known in the hills above the Croton River. Long before the arrival of the European settlers, this hillock was a sacred place to the Native American population of the area—likely even a burial ground. Many stones in the current graveyard predate the church. Reports from the commissioners for the water supply indicate that "stones, bones, and remains" were all removed from the encroaching waters to various churchyards. Oral tradition from locals, however, states that only the stones were moved.

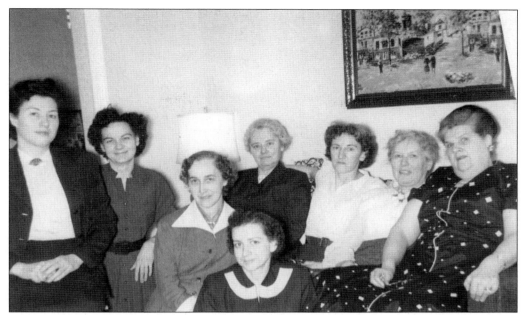

Farming was rapidly disappearing with the onset of suburbanization in the 1950s. The children of Huntersville remained close-knit for many years in groups such as this Ladies' Missionary Society in the late 1950s. Pictured, from left to right, are Marcena Downing Tompkins, unidentified, Irma Denison Tompkins, Dorothy "Dot" Wilson (floor), Hazel Wilson (couch), two unidentified women, and a Mrs. Young.

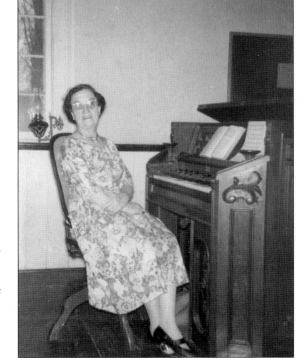

Ella Dyckman Losee sits at the foot-operated pump organ, purchased shortly after the Community Church was constructed. She played the pump organ for all services until an electric organ was purchased in the 1960s. She was the last member of the true Huntersville Community (beneath the waters) when she died in the early 1980s. The pump organ is still used for the hymn "Silent Night" on Christmas Eve.

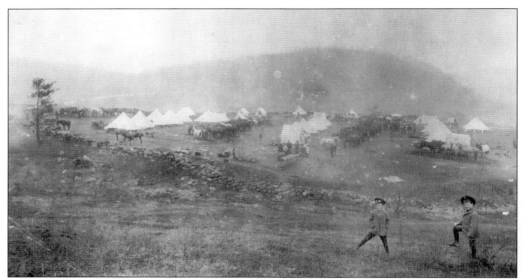

All was not peaceful in the Croton Valley during the construction of the New Croton Dam. With large numbers of immigrants and attempts to keep costs low came poor wages and labor unrest. The contracts signed in 1892 with ten-hour workdays conflicted with a 1897 state law requiring eight-hour workdays on public projects. By April 1, 1900, the impasse between labor and contractors at the dam turned into a full-scale strike, requiring the use of federal troops. This photograph shows Troop A of the 7th Regiment on April 21, 1900.

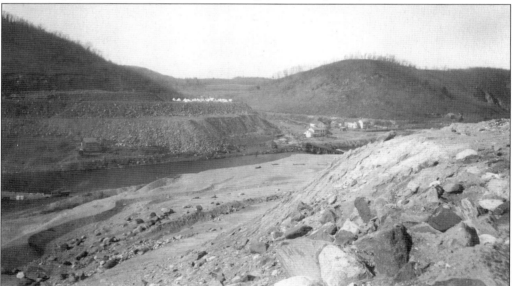

Most of the quarrymen and stonecutters were Italian, and the local law enforcement officers were Irish. This difference did not help reduce tension, as the two ethnic groups were adversarial. The laborers were heavily armed with guns, knives, and stones, and planned to fight for what they perceived as their rights to both a shorter workday and more pay—as the 1897 law seemed to require. Easter of 1900 found tensions high, but a truce brought both parties to Catholic Mass in Croton. This photograph shows a battalion of the 7th Regiment on the "Spillway Dump" in April 1900.

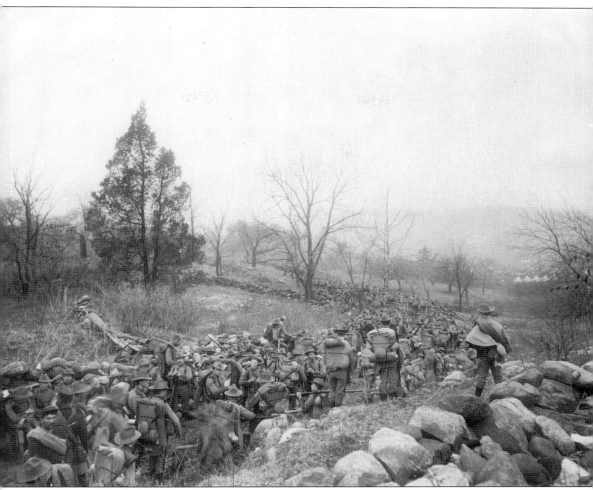

The arrival of the 7th Regiment at the New Croton Dam site on April 18, 1900, provided hope for the contractors and bitterness for the workers. Gov. Theodore Roosevelt is said to have come out to the site to meet with officers and to intercede. The main encampment of the troops became known as Camp Roosevelt and provided a level of stability in the area. The labor issues did not disappear overnight, however. It took almost two years for the labor contract to be amended in favor of the workers. In the meanwhile, workers who dared try to enter the work site were beaten by strikers. Many left the valley completely, and even the merchants became angry with their mounting losses. By the summer of 1902, wages were in line with the 1897 law, but new workers had to be brought in to replace those who simply left. Work on the dam was months behind schedule. The final result was a victory for the unions and the laborers at the dam: 8 hours rather than 10, and 17¢ per hour, up from 14¢.

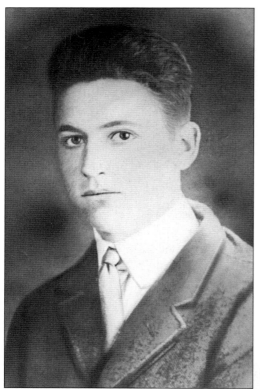

Two children of Jennie Mitchell Tompkins who were born after the completion of the dam knew life completely with the waters of the Croton Reservoir surrounding them. Their parents knew farming, but like many other old-time families, they found new types of work dictated by the Croton Dam, the developments it brought, and the changing times. John. M. Tompkins, pictured *c.* 1920, found work with the City of New York and became the superintendent of the Croton Reservoir. He worked for the city for 42 years, until retirement in the early 1970s.

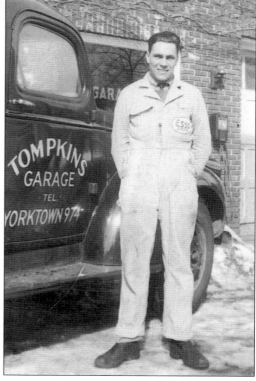

Henry Tompkins, shown *c.* 1940, took over what was one of the earliest gas stations and motor vehicle repair shops in Northern Westchester County. The name on the truck is the same name that is on the sign to this day. The Tompkins Garage has been owned by a member of the family since its founding *c.* 1912. Today, tourists who travel to the Croton Dam and fish in the reservoir often stop for directions and a Coke at this landmark.

View from Old Post Road Harmon-Croton Grade School

As the quiet hamlet of Croton and the remnants of Huntersville settled back into a rural pace of life after the dam's completion, those families who remained bore many children in need of education. The name Harmon comes from the landowner who once owned the property used by what is today the Metro-North Railroad station and repair facility. Croton thus became a two-name village, with Croton-on-Hudson its official name and Croton-Harmon its station name. This photograph dates to the 1920s.

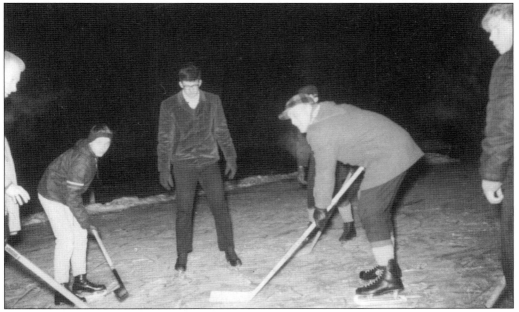

The Croton Dams and Aqueduct were far from the minds of the new generation of local teens in the post-World War II era. The many old millponds in the vicinity of the Croton Dam attracted children of all ages and abilities for winter play. "Pickup" games of ice hockey were common sights day and night. Bonfires were often spotted through the woods, as young people congregated to complete matches begun early on a winter's day. This photograph was taken in the late 1960s.

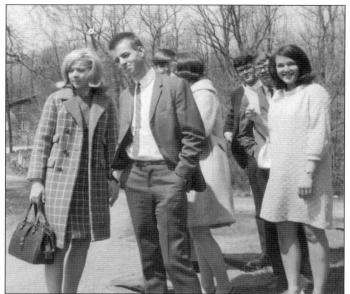

By the late 1960s, most young people's thoughts were on music, socializing, and school. Although these teenagers attended the same church that many of their ancestors had attended, the excitement and dramatic social changes of the times overshadowed the historical significance of their community. Many of these young people were soon to be called for duty in Vietnam, later to be buried next to ancestors who fought and died in all the preceding wars, including the American Revolution.

The graveyards of many churches were overgrown by the 1960s. The optimism of the Kennedy era called young people to focus on the future and on distant lands. Concerns for local community history were subjugated by urban renewal, civil rights, and volunteer work in the Peace Corps. However, a new use was found for the old graveyards, as optimism turned to apprehension and young people returned from Southeast Asia victims of the Cold War. Some of the young people who chose not to participate in the Vietnam War lived hidden away inside the tunnels within the Croton Dam. The dam was eventually sealed from the outside to prevent squatters of any type from finding a refuge.

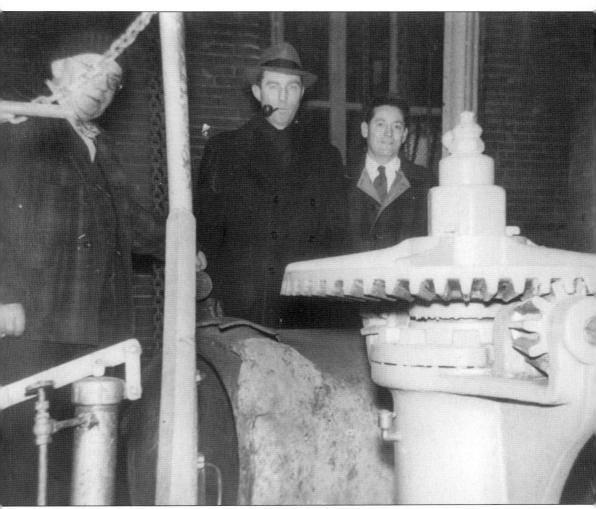

World events in the 1950s and 1960s impacted the lives and psyche of every American, but people turned on their taps for water with very little thought about where that water came from. Through all the turmoil of World War II, the Korean Conflict, and the Vietnam War, there was concern for the safety of the water supply which, for the most part, remained unprotected. The Aqueduct Police Force patrolled the area and the dam prior to the incorporation of the professional police force now in place. No guards, however, could protect city employees from the explosion of a chlorine tank at the gatehouse in the 1950s that was heard nearly a mile away. The culprit tank is seen above with, from left to right, an unidentified worker, chief engineer John H. Kelley, and superintendent of the Croton Reservoir John M. Tompkins. Today, a similar event would be classified as hazardous, warranting an evacuation. Then, gas masks were simply donned and those affected by the gas were pulled to safety. These chlorine gas tanks were carried to Croton Lake Station on the Putnam Division of the New York Central Railroad until its final demise in northern Westchester County in 1962.

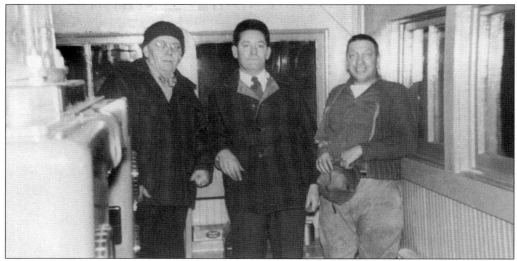

Despite the chlorine gas explosion, New York City needed water, so work went on maintaining the gatehouse, increasing and decreasing water supplied to the aqueduct, and treating water with chlorine. In the control room with the chlorination unit to the left are members of the gatehouse crew in the late 1950s.

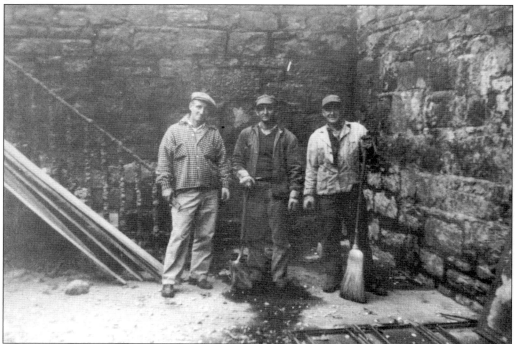

After a dramatic storm and the Flood of 1955, the reservoir was drained to repair the dam (see the next chapter). During the repairs, the gates of the 1842 gatehouse had to be opened for water to be drawn in from the old Croton Dam and Reservoir. Pictured in 1956, from left to right, are Howard Pickup, Frank Sylvia, and Ed Jarvis as they clean the old gatehouse for temporary use. Note the corrosion on the handrail behind them from nearly 50 years of submersion under the lake.

Seven

THE TEST OF TIME

As the New Croton Dam settled into the daily mind-set of local inhabitants and New York City residents forgot their concerns about water, the dam, aqueduct, and reservoir became weathered landmarks. Fishing replaced frenzied masons, and strolling on the dam replaced the old chugging of steam engines. The engineering feat of the early 1900s was fading from prominence until a 100-year flood in 1955 brought the dam back into the limelight.

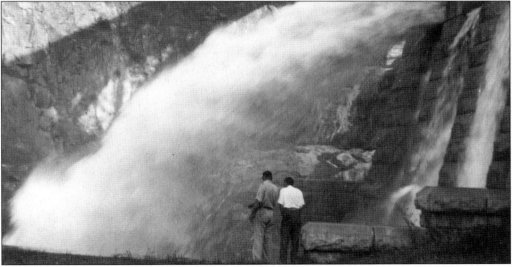

On August 3, 1956, No. 1 blowoff opened to begin draining the Croton Reservoir for extensive repairs from the previous year's flood. Lester Wilson and Paul Wetzler observe the torrent from the retaining wall above the riverbed. Wilson was one of three dam keepers during the postwar era. He, Harvey Anderson, and Henry Bochan worked at the dam seven days a week and were responsible for the upkeep of the lawns, gates, and park, as well as water measurements and monitoring of the aqueduct. They worked from a small building with no running water, only a spring, and had to use an outhouse. Following the closure of the old aqueduct to city-bound water, these positions were eliminated, resulting in a dramatic reduction in the upkeep of the dam and the park.

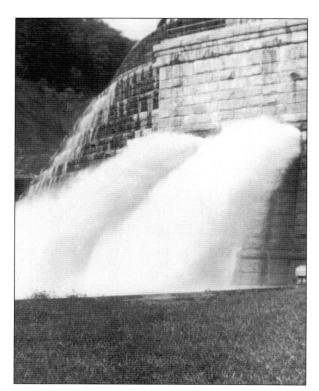

Two blowoff relief gates open at full blast. The water cascades down the spillway in the background and flows through cracks in the dam created by the pressure of a 4-foot wall of water that poured over the dam after a major storm swept through the area October 14 and 15, 1955.

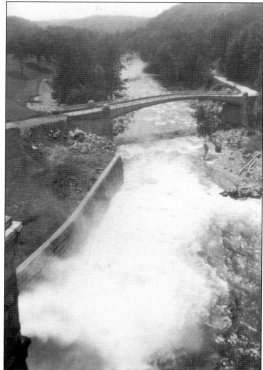

This view was taken looking downriver from the blowoff. Note the heavy damage done to the left bank of the river and the extensive repairs to the bridge, which was almost swept away.

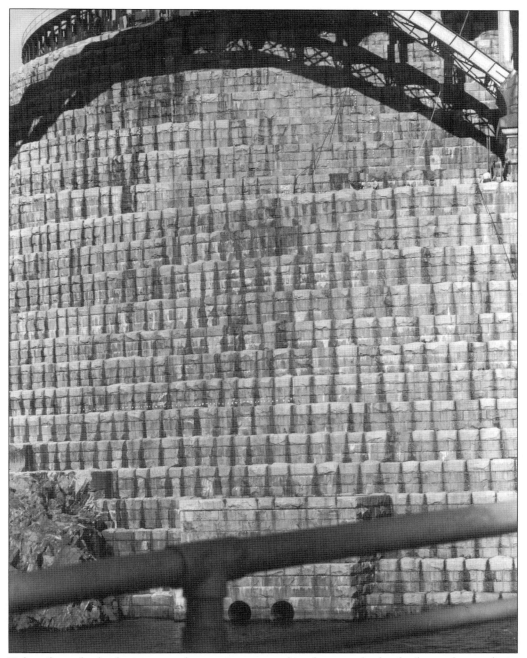

Taken from the bridge seen on the previous page, this photograph clearly shows the cracks in the masonry, as denoted by the white dotted lines in several locations on the spillway. The holes at the bottom of the dam are the sealed gates of the old riverbed tunnel used during the construction project.

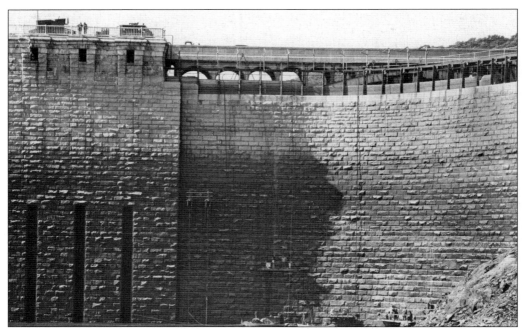

The rear of the spillway is marked with white paint to show the cracks needing repair. Boats had to be tethered so as not to be pulled toward the intakes for the blowoff (left). The cement extension with catwalk is in the process of being removed so that the height of the reservoir and the pressure on the dam would not be so great again as to cause further damage.

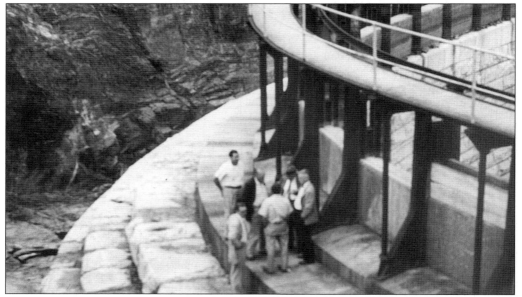

John Tompkins, Roy Bickwit, Fred C. Stern, Edward Clark, and Al Guaci confer while standing nearly 180 feet above the riverbed. When crews went into the dam to check it during the flooding, they are said to have left shaking from the incredible vibration and thunderous roar emanating from the spillway. Below the dam, houses were torn from their foundations by the enormous flow of water.

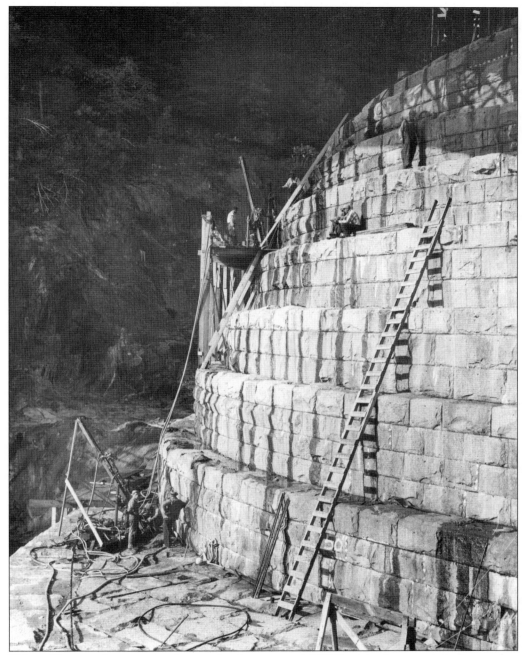

Taken 50 years after construction on the dam stopped (1956), this photograph indicates that certain methods of masonry work remained the same. The long wooden ladder, scaffolding, and lack of hard hats, eye, and ear protection are all similar to the scene in the early 1900s. The clothing is the major change from that time.

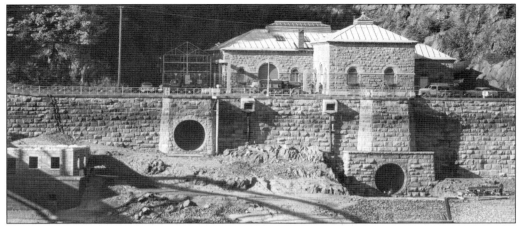

The draining of the Croton Reservoir provided an opportunity to complete repairs to the intake tubes at the aqueduct gatehouse. New grates were being welded on the lake bed to the right of the middle intake. The structure to the lower left is what remained of the old gatehouse from 1842. This view has since been obscured by the completion of a third gatehouse, which dwarfs its predecessors and sits in the foreground directly over the intakes.

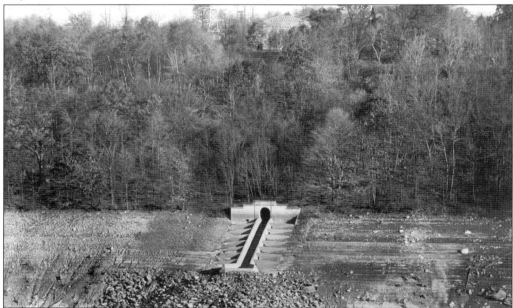

The dry lake bed reveals a lunar landscape bearing little resemblance to the once fertile valley. The structure in the center is the "blowout" connecting the Catskill Aqueduct (c. the 1930s) seen above in the trees. Water heading to New York City via the Catskill System could be diverted into the Croton System at this point. When used, the water moved with such force that it sprayed across the entire lake. The farm above the blowout was the Chapman Estate. During World War II, Mr. Chapman's caretaker, an elderly Japanese man named Ishi, walked to Route 129 to pick up the mail. One of the officers of the Aqueduct Police Force ordered him to stop along the road, but he was hard of hearing and did not comply. The officer hit him in the head and took him into custody before realizing who the "offender" was. No further action was taken against either party.

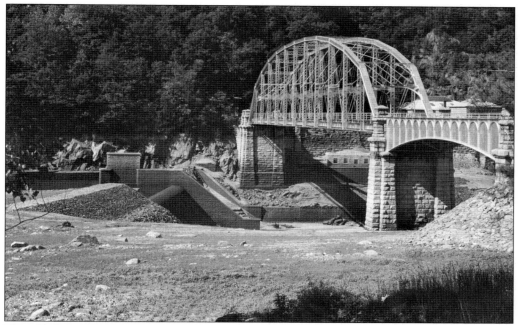

The old Croton Dam was completely visible during the 1956 draining, which was done for the first time since the lake was filled a half century earlier. The Arcady Road Bridge, or "Thunder Bridge," as locals called it because of its wooden plank deck, offered a dramatic comparison against the size of the old dam and gatehouse seen underneath. Today, the bridge has a steel deck that no longer punctuates the silence of a summer's night with "thunder."

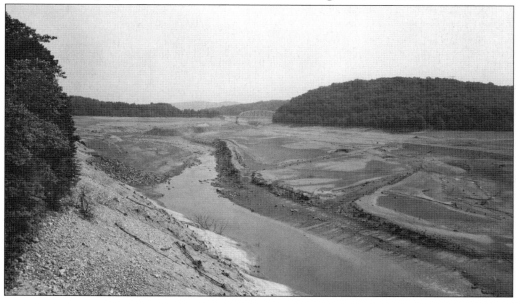

The eerie view of the old riverbed amidst the barren landscape was a worrisome reminder that New York was without the Croton Reservoir for the duration of repairs. The only Croton water entering the aqueduct came from the intake above the old Croton Dam. When opened for the first time in 50 years, tree stumps and other accumulated debris were swept into the tunnel.

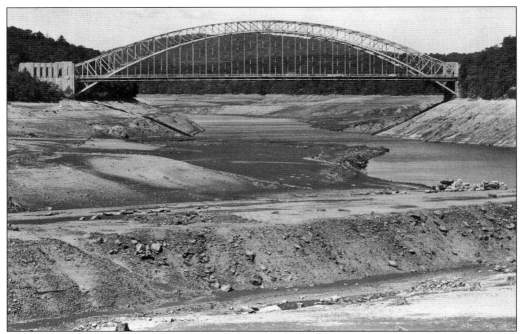

Looking downriver from the gatehouse, the Taconic State Parkway Bridge in 1956 loomed as the largest span across the lake. Built as part of Pres. Franklin D. Roosevelt's New Deal, the Taconic Parkway remains a favorite road for peaceful drives and commuters alike. Before the 1970s, this bridge carried traffic north and south until a new bridge and rock cut were completed, making travel safer and faster for all concerned.

Many things were found on the lake bed immediately beneath the Taconic Parkway Bridge during the draining of 1956. This sawed-off shotgun was one of the more sinister items thrown off the bridge, no doubt, in hopes that it would disappear forever. The owner probably never expected that a flood would force the draining of the lake.

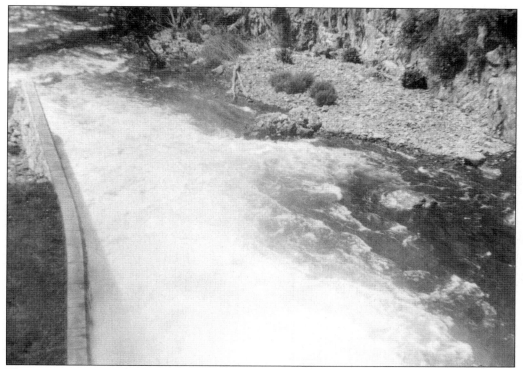

The raging waters of the draining lake created a superb habitat for the remaining trout population below the dam. The billions of gallons of water lost through the blowoff gates reached New York City mixed with the waters of the Hudson River, rather than through the aqueduct. In 1956, the water of the Croton River must have provided some much needed clean water for the Hudson.

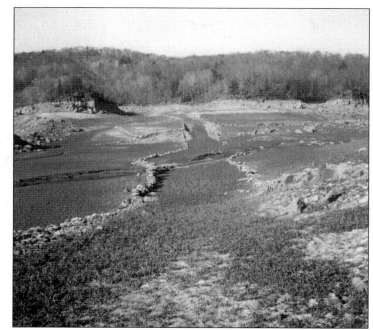

Above the new dam, little water was running in the summer and fall of 1956. From the old dam to the new, the Croton Valley became a barren wasteland where old roads, such as this one, coursed over an empty landscape. The wooded hills surrounding the dry lake are indicative of the return of forests, as farms all but disappeared in Yorktown.

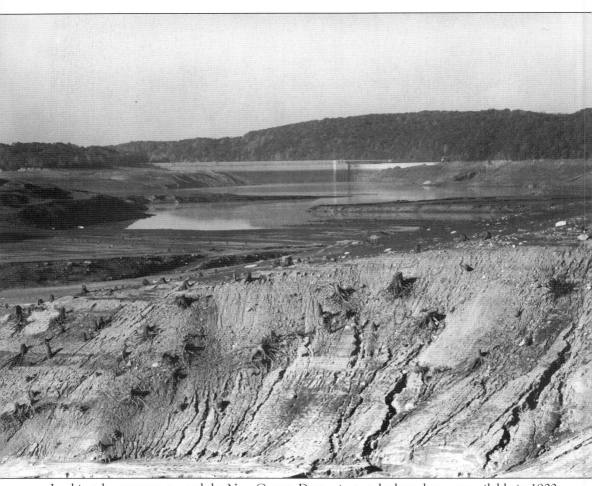

Looking downstream toward the New Croton Dam using a telephoto lens, unavailable in 1900, the sheer size of the project is clearly visible. Several thousand workers, hundreds of farms, thousands of trees, and several million New York City residents later, the dam was as remarkable in 1956 as in 1906.

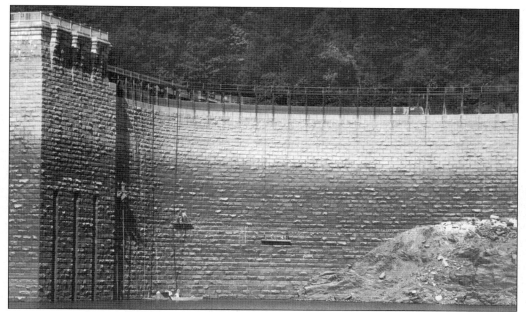

As workers repaired the cracks, they were continuing the work of the men who had raised the dam 50 years earlier. Updating the spillway and improving the structural integrity of the dam was essential to the future of the New York City water supply. Plans are currently under way to rebuild the section of the dam atop the spillway to raise the water of the reservoir to its original, planned levels.

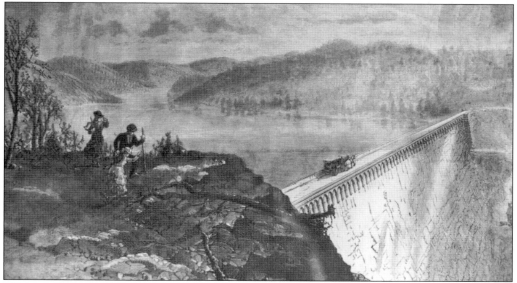

The crews hanging from scaffolding saw a dam in trouble in 1956. This c. 1870 print envisioned a serene setting for hikers and carriage rides. Indeed, the dam today affords residents and visitors such a setting, and there is little concern regarding the structural integrity of the dam. Daily, there are bikers and hikers on the dirt road along the south shoreline and along the favorite "aqueduct trail" from the dam to Ossining. These trails connect with the Teatown Lake Reservation trails and the Peekskill-Briarcliff Manor Trailway.

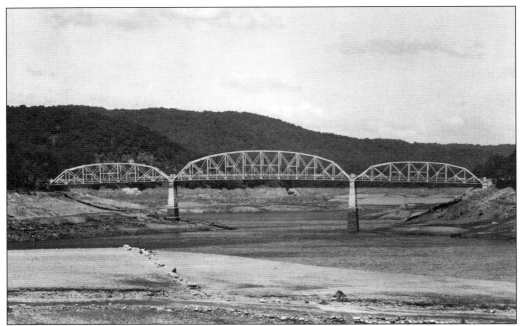

The Hunter Brook Bridge and its surroundings represent one of the Croton Reservoir's many beautiful views. The stone walls on the lake bed are all that remained of the farms of Huntersville, though many families still live on family property along Route 129 to this day.

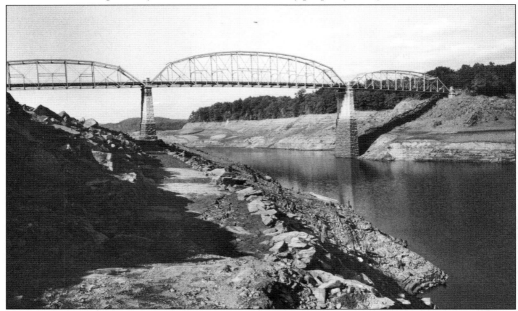

The old road up toward the bridge came into view in 1956, as the lake drained and the Hunter's Brook once again flowed along its natural course. The small black object centered above the bridge is a Piper Cub airplane that has just taken off from a small airport above the bridge. In the 1970s, a plane crashed into the deepest part of the lake upon takeoff. The airport subsequently closed.

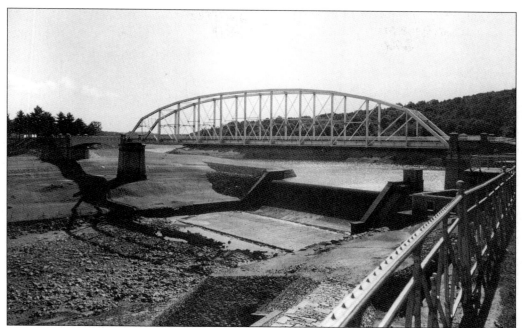

The summer of 1957 was drawing to a dry close with the old reservoir shimmering, but well below the lip of the old dam. School was in session by the time this photograph was taken. While repairs were being completed on the New Croton Dam, the town of Yorktown was preparing to build several new schools to accommodate dramatic increases in student population. Between 1950 and 1970, graduating classes from Yorktown High School grew from an average of 25 to more than 400. Another influx of immigrants (this time New Yorkers seeking suburbia) was arriving in northern Westchester County, attracted by the beauty of the landscape and the rural flavor of the Croton Watershed. Few of these newcomers ever saw the old Croton Dam, but they did come to know the New Croton Dam for its beauty and grand scale.

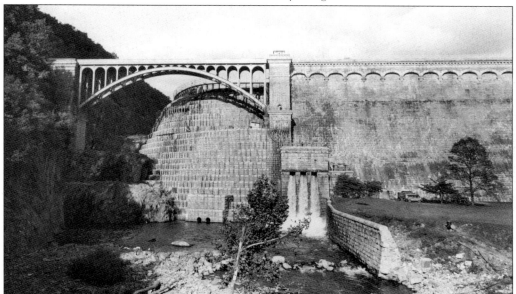

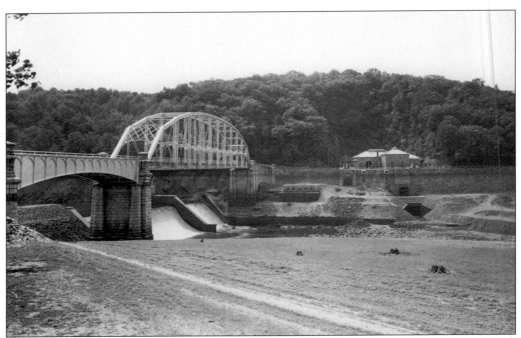

In September 1956, as water came over the spillway of the old dam for the first time in more than 50 years, the pace of change in Westchester was putting environmental pressure on the watershed. Just beyond the city-owned canopy of forests around the lakes, new growth outpaced the capacity of the local infrastructure. To this day, vast areas of the watershed remain without town water and still use septic tanks for sewage disposal.

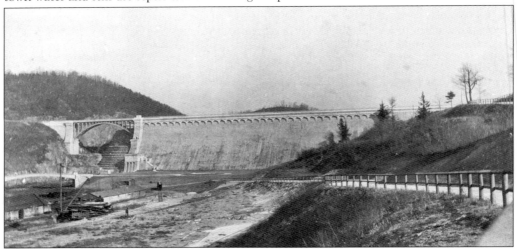

At its completion, the "mother dam" of the Croton Watershed, with its multilake, multidam system, was expected—as in 1842—to last for centuries. Demand for water combined with extreme environmental pressure have required conservation and protection. Invoking a 19th-century law giving it special power over the Croton Watershed lands, the City of New York has exerted powerful influence on the towns of Northern Westchester to restrict development. The same ample water supply and the beauty of the surrounding area that created growth are now the watershed's worst enemies.